LEAMINGTON &WARWICK
DISAPPEARING INDUSTRIES
From Old Photographs

Jacqueline Cameron

AMBERLEY

Lockheed Automotive Products Limited · Flavel's Foundry · Imperial Foundry · Ford Motor Company Limited · Midland Red Omnibus Company · Leamington Priors Gas Company · Henry Jones Museum · Mr J. Clarke · Andrews' Furnisher's and Upholster's · Eagle Foundry · Potterton's · Midland Autocar · Desmond Hotel · Bellman's Scotch Wool Shop · A. C. Lloyd's · W. C. M. Pattern Company · The Whittle Factory · E. Francis and Sons · Burgis and Coldbourne's · Nelson Cement Works · The Claredon Hotel · Thomas Hunter Limited · Gardner Merchant · Crowden Motor Works · Elm Farm Dairy Company Limited · Bailey's Furniture Store · Warwickshire County Garage · Harry Crawley's Tailor's · Henry Griffiths and Sons · Lockheed Hydraulic Company · Regent Hotel · West End Garage · Borg and Beck · Supercar · Cape Engineering · Walwyn Pumps · Industrial Mouldings · Benford's · Hitchman Laundry · Vic Darlow and Mr Hunt · G. Orange · Truslove and Harris · A. H. Hayes and Company · P. H. Woodward and Company · The Spa Fancy Bakery · Sensicle and Son · Donald Healy

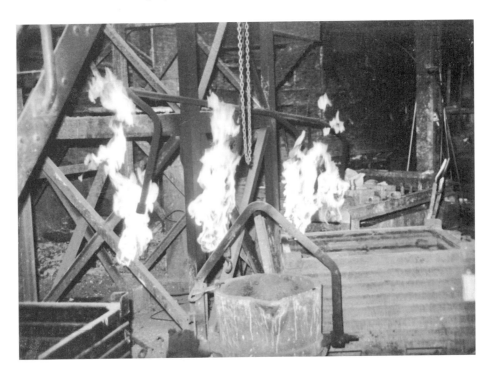

Dedicated to Bob whose support I can always rely upon.

First published 2010

Amberley Publishing Plc
Cirencester Road, Chalford,
Stroud, Gloucestershire, GL6 8PE

www.amberley-books.com

Copyright © Jacqueline Cameron 2010

The right of Jacqueline Cameron to be identified as the Author of this work has been asserted in accordance with the Copyrights, Designs and Patents Act 1988.

ISBN 978 1 84868 602 1

British Library Cataloguing in Publication Data.

A catalogue record for this book is available from the British Library.

Typeset in 10pt on 12pt Sabon.
Typesetting and Origination by FonthillMedia.
Printed in the UK.

Introduction

I have had it in mind for a long time to try and recapture in photographs some of the many industries that have disappeared from Warwickshire over the years. It was clearly going to be a mammoth task and, until I had visited the Motor Museum in Coventry, I hadn't realised just how big a task I had undertaken. There were eight hundred companies that disappeared from Coventry alone, including those of omnibuses, motorcycles and motor cars. Up until the early 1970s, Coventry was part of Warwickshire, but although it is a lot closer to the Shire town than a good many other towns and villages in the county, Government, in their wisdom, decided to place it in the West Midlands. In the period I am interested in recording, Coventry was still in Warwickshire and I would like to include it in a later edition of this book. Having said this, my plan, using a wide collection of photographs, is to recapture for posterity the history of the businesses of Leamington and Warwick from as early as possible until their closure. Barring one, all the companies I am writing about have one thing in common: they have disappeared!

In the early days the people of Warwickshire relied upon farming and domestic work to make a living; there would always be a cheap and plentiful supply of domestic servants. The discovery of spa waters in Leamington made it a tourist attraction and brought prosperity. Hotels began to spring up, shops opened to cater for the influx of visitors, and industry began to take note of the region's potential. There was easy access to Birmingham and London, an ample supply of labour, and increasing wealth brought by the more affluent, flocking to be near the spa waters.

Companies like Lockheed, Borg and Beck, Ford Motor Company Limited, Donald Healey (famous for his sports cars), Sidney Flavel, and Thomas Potterton were established in Leamington and flourished. There were also smaller employers like Supercar in Warwick, manufacturers of fairground rides, who also had a factory on Gunnery Terrace in Leamington Spa, Cape Engineering, famous for its Iron Lung manufacture, Walwyn Pumps and the Industrial Mouldings. These businesses combined to set Leamington and Warwick on the road to becoming boom towns. There was Eagle Engineering, who manufactured dust carts, and Benfords and Thwaites, both manufacturers of the dumper carts. There were laundries like Hitchman Laundry of Leamington Spa and the Warwick Laundry in Warwick, and smaller laundries like Harris's, which conducted business on the Rock in Warwick and employed forty staff. These laundries would open shops in town where people could take their washing and their vehicles to collect it.

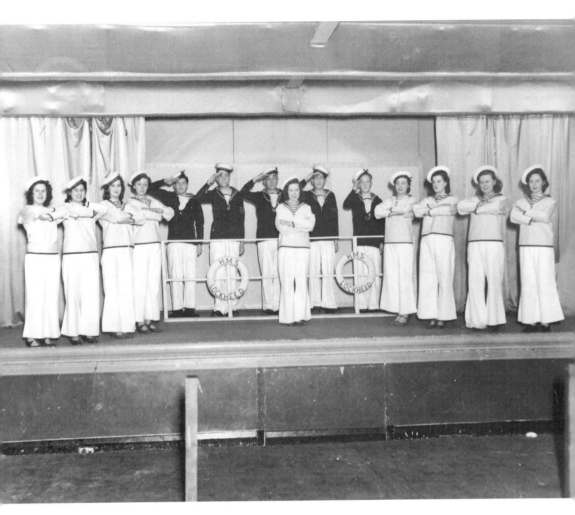

Workers' Playtime:
Photographed in the works canteen at the Automotive Products Limited in the mid 1940s.

Even smaller companies thrived, like Vic Dillow and Mr Hunt the Coal Merchants, Clyde Higgs the Milkman, and Mabel Buswell and her horse-drawn cart selling vegetables, ably assisted by her father.

I can well remember a gentleman on a bike, whom my mother affectionately referred to as 'fishy', with a huge cane basket on the front, calling on us on Tuesdays and Fridays with a parcel of fish wrapped in white paper and tied with string, with my mother's name written on it in large black letters. Fridays were always fish days, and these were the days when the Sabbath was observed. I never knew where 'fishy' came from or whether he was a one-man band, but what I can recall is you would have to go a long way, even today, to find fish as tasty as those that came out of his packets!

The corner shops also came into their own; when the rationing had passed it was a boom time even in this area, with shops popping up everywhere. There were no supermarkets back

then. We had a lovely lady called Kip who ran our corner shop in Warwick, ably assisted by her man friend Harry and her mother, Granny Griffin. Granny Griffin had a large collie dog called Biffin and a parrot, affectionately called Polly, who pecked! She also squawked and talked a lot, and Kip would often shout from the shop, 'Mother, shut that bird up!'

I well remember the liquorice factory in Theatre Street where, as children going to Westgate School, we were always lucky enough to be offered a bit of liquorice from the back door on our way home!

Industry attracted people to the area; they needed houses to live in so Estate Agents like G. Orange, whose office was in Warwick Street, Leamington Spa, and Truslove and Harris sprang up. Furniture stores began to appear: Bailey's the Furniture People in Warwick Street, Leamington Spa, A. H. Hayes and Company on the Parade, P. H. Woodward and Company, Drapers and House Furnishers on the corner of Regent Street and the Parade. They were all large stores and employed a number of people. Food was another industry that prospered: The Spa Fancy Bakery, Sensicle and Son Limited, M. J. Crawley the Pork Butcher in Leamington, and, of course, the smaller outlets like Ben Cowley in Warwick, whose eponymous owner was one of the town's characters. Schools like the Wright School of Dancing in Victoria Terrace, Leamington, and Jessie Fay's School of Dance started to spring up. Secretarial colleges, where people learnt shorthand, typing and book keeping, were also in demand. June Warmington in Holly Walk and Isobel Brown were both very successful in this field. Builders were attracted to the area to cope with the demand for new houses; The Midland Building Supply in Radford Road, George Waller of West Street, Warwick, A. Ballanger Building Merchants of Kenilworth Street, Leamington Spa, and Court and Company from Portland Place all enjoyed a building boom.

In fact, a business did not have to be a big employer for it to have an impact on our disappearing industries. James Simms in Satchwell Street, Norman Engineering in Warwick, Wallwin Pumps (which had two factories), J. L. Vaughan and his cycles in 9 Old Square, Warwick, Wakefield Engineering Company in the Saltisford, Warwick, Leamington Pattern Making Company in Ranelagh Terrace, Avon Bodies, Buckingham's Sheet Metal Works, Wedgenock Welding; the list goes on.

It's not until you start to list these industries that you realise what a loss their disappearance has been to the towns. The Trustee Savings Bank in Victoria Terrace was the working man's bank. Radio Rentals were a God send when you needed a mortgage to purchase a Bush television in the early days. Simms and Hessings were also retailers of electrical equipment.

I have not been able to mention all the businesses which have disappeared over the years, space would not permit me, but I have tried to give you a rough idea of the enormity of it all; I hope that, despite the sadness, this book will bring back memories of the days after the Second World War, when Leamington Spa and Warwick were starting to prosper again.

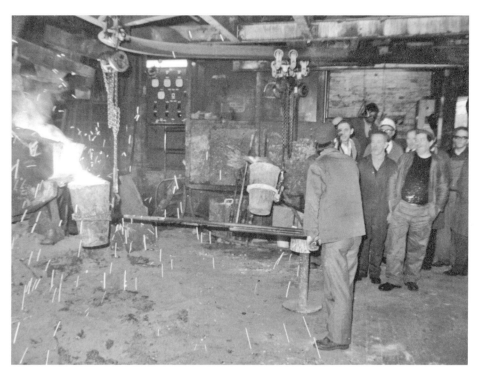

Pouring Through Time:
I love these two photographs as they typify exactly metal making through time. The top picture shows the manual way of making metal, and the bottom picture shows the vertical flaskless moulding machine, with a near perfect pour.

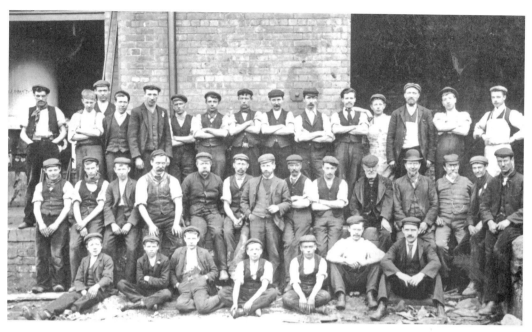

Flavel's Foundry:
The staff of Flavel's Foundry, Princes Drive, around the turn of the twentieth century.

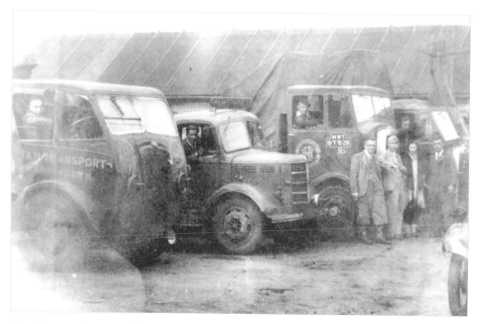

War Years at the Imperial Foundry:
During the war, the Imperial Foundry manufactured tracks for various types of tanks, including the famous Churchill tank. After production, bren gun carriers, which were also manufactured by the company, and the Churchill tracks were moved to Warwick Station by three Scammel mechanical horses, supplied by H. and H. Transport of Kenilworth. Here we see Harry Cox and colleagues waiting for their next load.

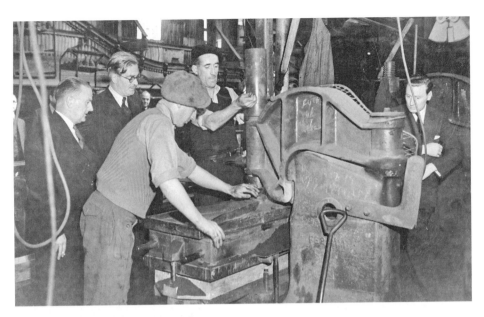

The Right Honourable Anthony Eden:
The Right Honourable Anthony Eden MP, who was later to become Prime Minister, on a visit to the Imperial Foundry, Royal Leamington Spa. Mr Whitlock, works superintendent, left, explains machine moulding.

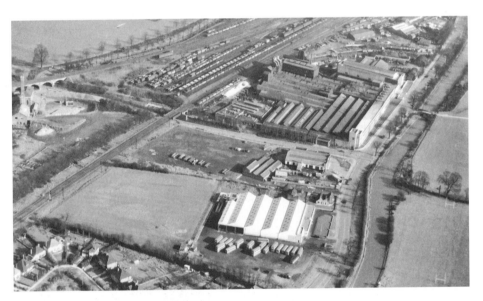

Aerial View of the Midland Red Garage:
The viaduct carried the main railway line into Leamington Spa. In front of it is the old destructor building, demolished when the unit was modernised in the 1980s. The double-decker buses in the centre belonged to the Midland Red Omnibus Company, who operated a works garage in the Myton Road, originally the old Turnpike road. The rugby pitch met its end with the diversion of the canal in the early 1990s, and is now a modern housing complex.

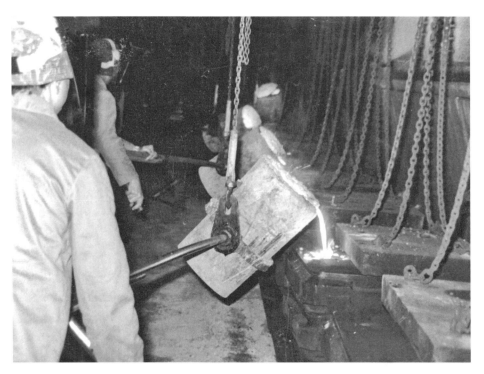

On the Lines:
Pouring metal on the moulding lines at the Ford Motor Company, Leamington Spa. This was a very dangerous job and it was quite common for the pourers to suffer serious burns from the hot metal.

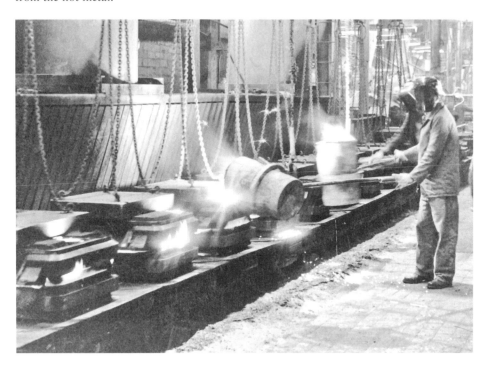

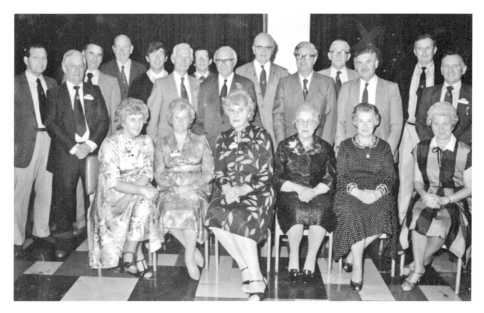

Twenty-Five Club:
Known as the Twenty-Five Club, the employees seen here have all given twenty-five years faithful service at Lockheed. The lady third from the right in the front row is Miss Jessie Bishop, who for many years successfully ran the typing pool at Lockheed with a rod of iron! Originally from the London area, she was an evacuee to Leamington during the Second World War.

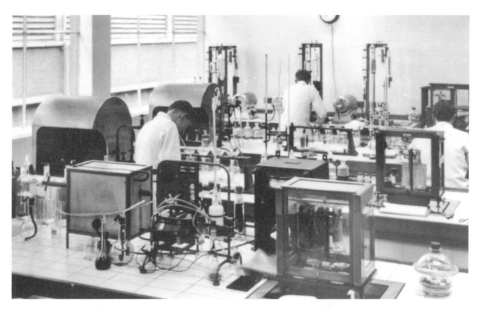

The Chemical Laboratory:
No business is run successfully without its support team, and foundries are no exception. The chemical laboratory played an important part in the analysis of the mix used in the manufacture of castings at the Imperial Foundry. Here we see Mr Mather and Ginger Wilkinson.

Lockheed's famous Post Room Supervisor:
Here we see Doris Favel who supervised the post room at Lockheed Automotive Products
from 12 June 1946 until her retirement on 2 June 1961.

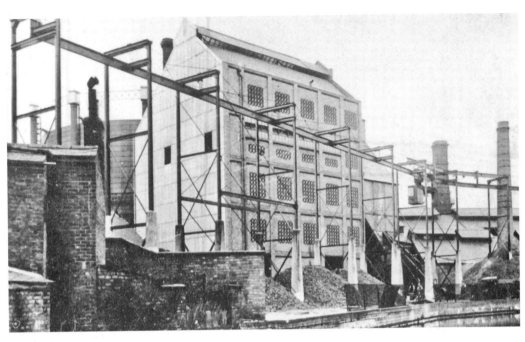

Gasworks:
Glover-West vertical retorts at the Leamington Priors Gas Company.

Henry Jones Museum:
Henry Jones was a burly, robust man, brought up as a shoemaker by his father. His mother died when he was very young. At the time of the Crimean War, Henry Jones turned his thoughts to the museum in Stratford upon Avon. His aim was to create exhibits from the roots of trees of every size and kind and exhibit them for people to come and admire. He was famous for his 'Shakespeare's Bust', which was a proud exhibit in the museum. Although it attracted visitors from all over the country, his little industry is sadly another casualty of time.

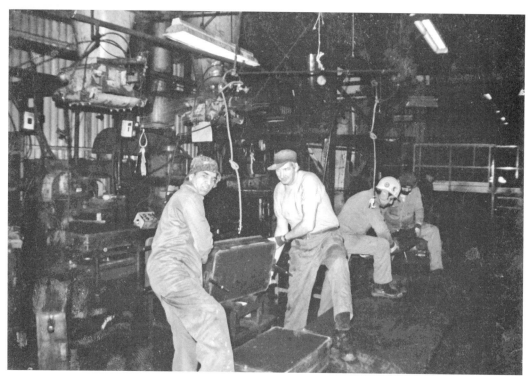

As we were:
Here we see employees at the Imperial Foundry.

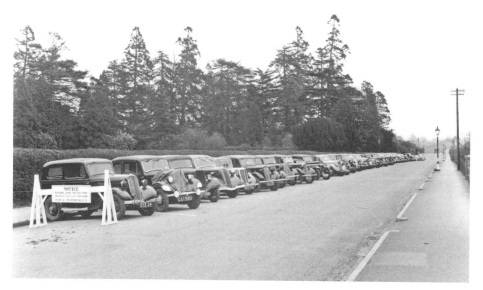

St Helen's Road:
I love this little piece of Automotive Product's history. On 15 April 1941, the car park in St Helen's Road was used by the employees to confuse enemy aircraft by separating the factory from the cars. Notice the black-out on the cars lights?

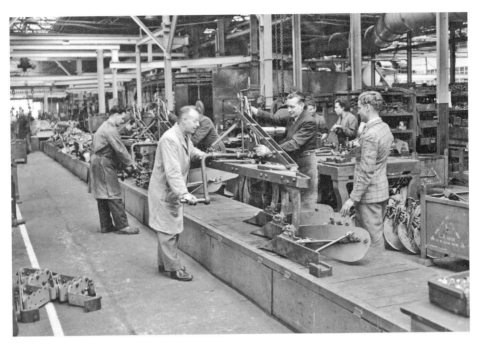

No. 2 Machine Shop:
Here we have a view of part of the number two machine shop, engaged entirely on tractor parts for Dagenham, at the Imperial Foundry.

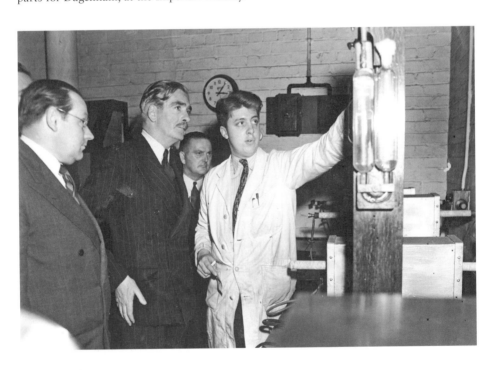

Anthony Eden MP:
A technical point is explained in the laboratory at the Imperial Foundry.

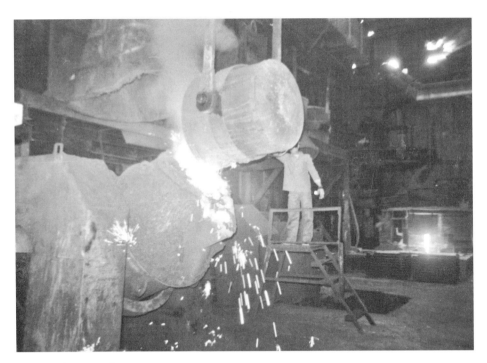

For the Pleasure of:
There is something magical about molten metal being poured. I have watched the procedure many times over the years, and I still get the buzz of excitement some forty years later after seeing metal poured for them for the first time.

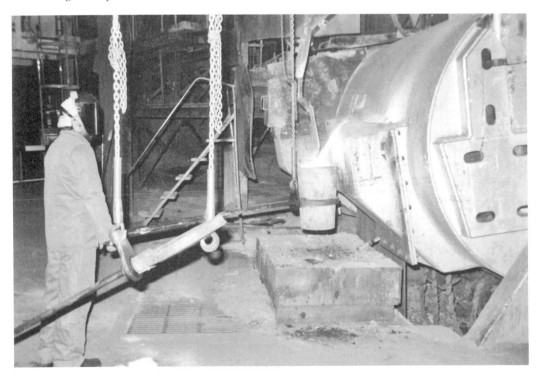

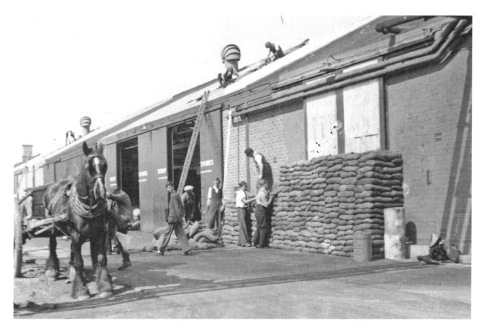

Sandbags:
Delivery of sandbags in 1939 to protect the power station at Automotive Products; the building to the left is the scrap store in Block One.

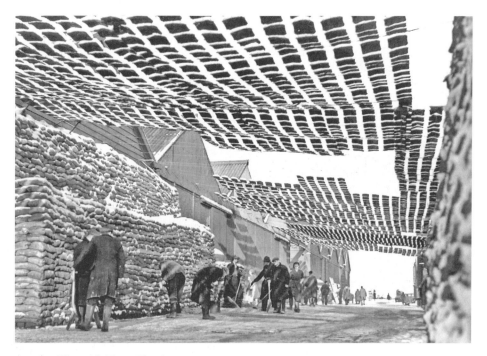

Another Through Time Classic:
Camouflage netting stretches across the first crossroads at Automotive Products in January 1941.

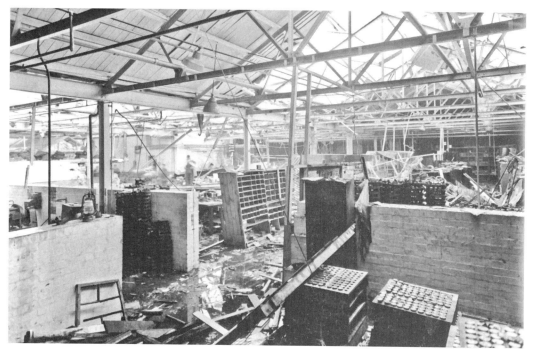

The Aftermath of War:
The scene left after the bombs had dropped on Lockheed Automotive Products in the Second World War.

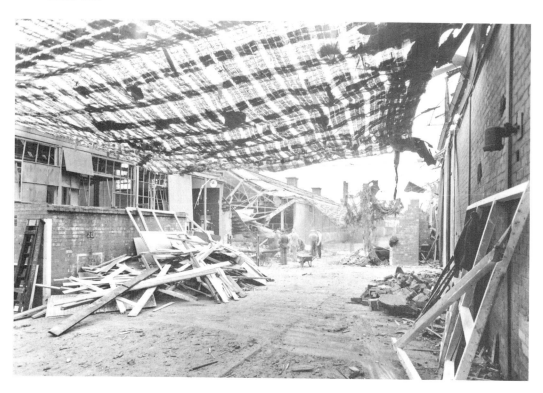

Miss Bishop:
This delightful photograph is of Miss Bishop, who ran the typing pool at Lockheed Automotive Products on Tachbrook Road, Royal Leamington Spa, for many years with a rod of iron! Here we see members of the Twenty-Five Club giving her a tremendous welcome.

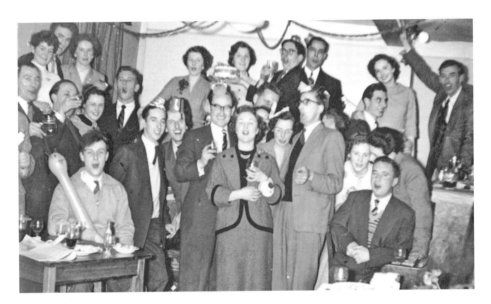

In Party Spirit:
Photographed in the 1950s, the Imperial Foundry office party put everyone in fine spirits for the festive season. Back row, left to right, is Roy Harding, -?-, Ken Hydon, Pat Green (?), Willy Green, John Everitt, Betty Everitt and Sid Thornton. Middle row, left to right, is Jim Butcher, Mrs K. Hydon, -?-, Bill Shead, John Moore, Jo Olds and Colin Haywood. In the front is Fred Goodchild and Frank Wall.

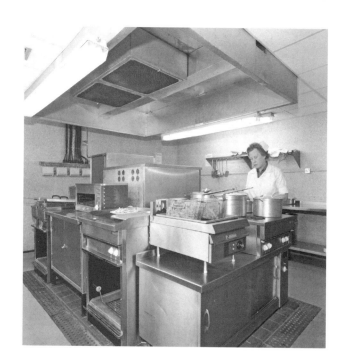

Gardner Merchant:
Anne Shirley working away in the Gardner Merchant kitchen at the Ford Motor Company's Queensway plant.

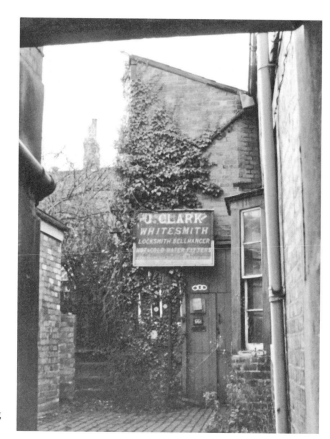

Mr J. Clarke:
Businesses come large and small and this one comes under the latter category. Mr J. Clarke was tucked away off Clarendon Avenue at number 66 1/2.
He offered the services of a locksmith and whitesmith among others.

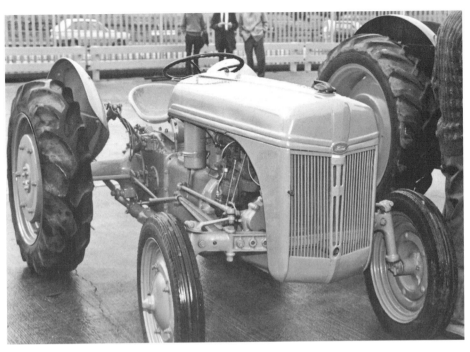

Ford Tractor:
A Ford tractor manufactured at the Imperial Foundry.

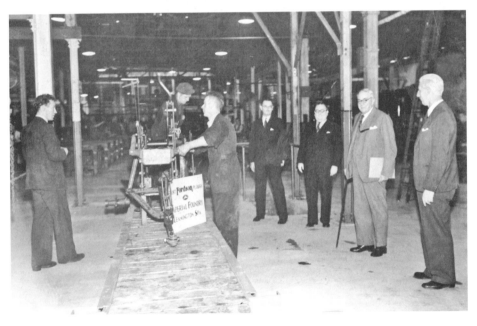

The Plough Share:
This delightful photograph is of the plough share assembly line at the Imperial Foundry. Always welcome, the Mayor's yearly visit was enjoyed not only by the VIPs, but by the company itself.

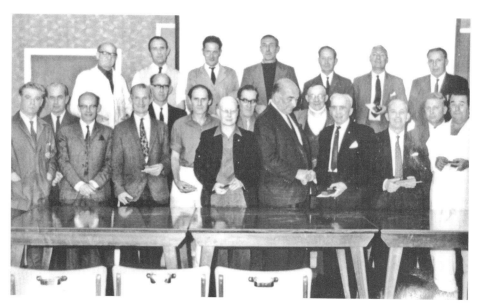

In the Fifties:
Ces Manley, personnel manager, is giving a presentation at the Imperial Foundry.

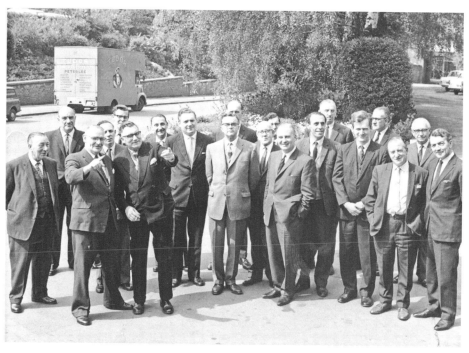

Group Visits:
Group visits were a popular event in the post-war years, and here we see one such event, photographed in the 1950s. From left to right are Ces Manley, George Jackson (plant manager) (?), Barry Monk (?), Mr Streeter, -?-, Mr McCartney, -?- and Anthony Rayment (assistant manager of the Imperial Foundry).

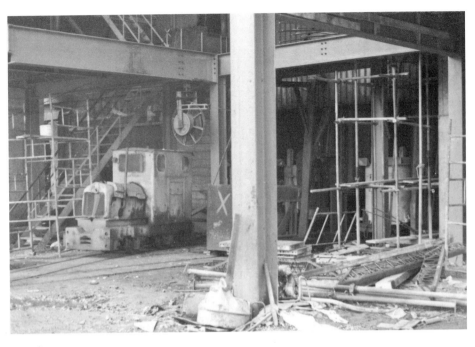

Diesel Loco:
The diesel loco under the platform being constructed for the new electric melting facility in 1978.

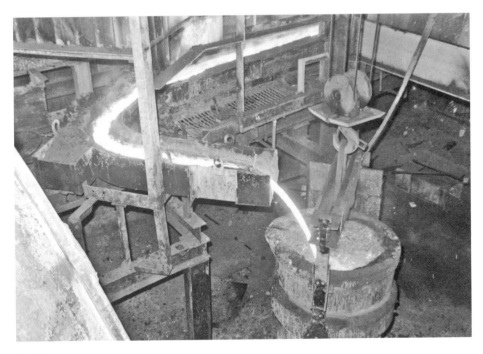

Smelting:
Metal pouring at the Ford Motor Company.

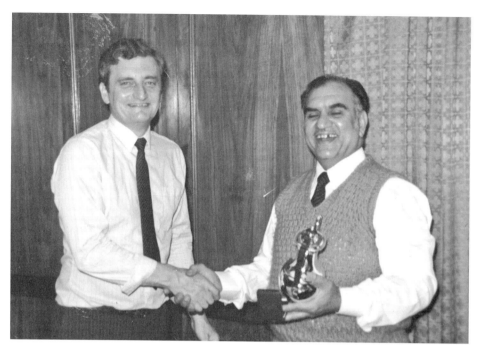

Presentation:
Here we see Bruce Bell (plant manager) and Mr Sharman enjoying a good joke during a works presentation. Mr Sharman was a foreman for many years at the Ford Motor Company.

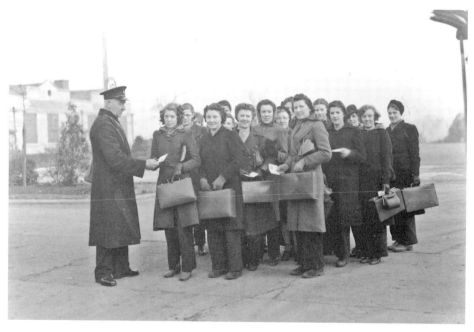

A Bevy of Young Ladies:
On 25 February 1941, a bevy of young ladies arrived at Automotive Products from Leicester. There were various hostels in town offering them accommodation.

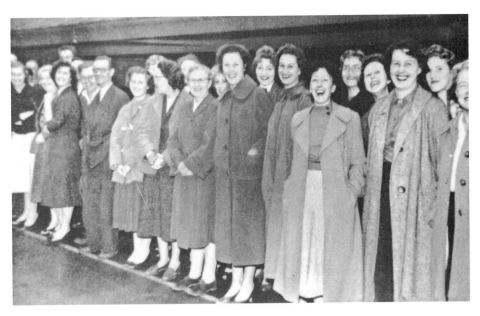

Lockheed's VIP:
HM Queen Elizabeth the Queen Mother visited the Lockheed Automotive Products in Tachbrook Road on Thursday, 6 November 1958.

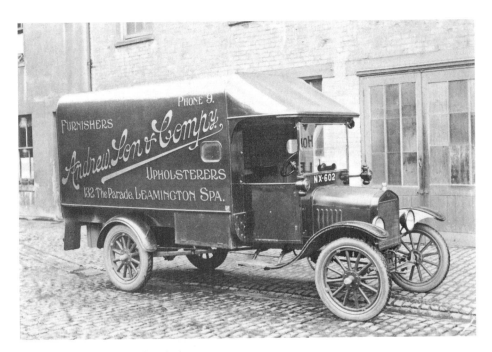

Andrews' Furnisher's and Upholsterer's:
Mr William Andrews, in partnership with Mr Taylor, took over the business of cabinet maker's and home furnisher's from Blakemore and Company in 1883. With the departure of Mr Taylor from the business in 1899, the business continued trading as Andrews and Son. The company decorated and furnished halls for dances and other social events.

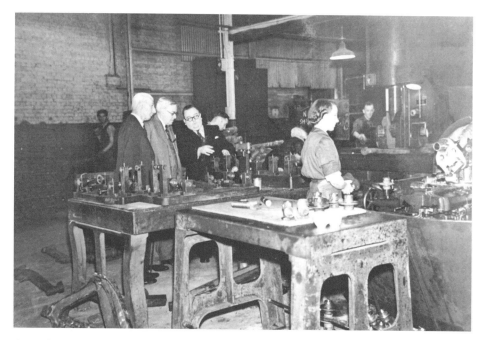

Core Shop:
The core shop of the Imperial Foundry sometime in the 1940s. The man in the centre is the works manager, Mr Fox, explaining what's going on.

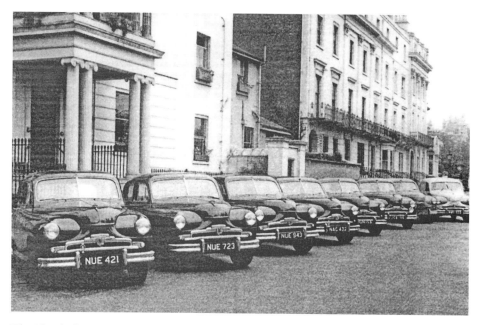

The Flavel Fleet:
Photographed in the early 1950s, this fleet of Standard Vanguards formed part of the Flavel fleet of vehicles. The elegant houses on the right were demolished in the 1960s, and the site now hosts the newly built County and Magistrates Courts.

Eagle Foundry:

A drawing of the Eagle Foundry in 1867. This was drawn after further extensions to the foundary. The lovely pleasure gardens adjacent to the Eagle Foundary were the Ranelagh Gardens, which were a firm favourite with the Prince Regent and the Royal family, who would visit the gardens on their visits to Leamington Spa. Below is an etching of the foundry in 1856.

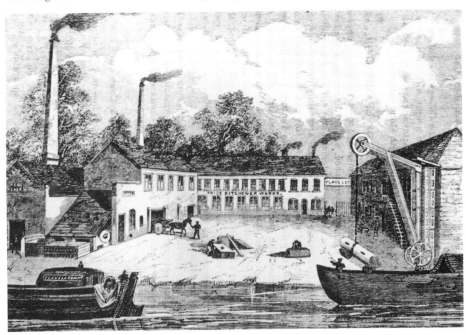

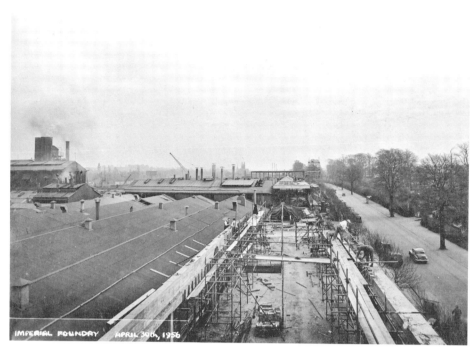

Imperial Foundry:
Scaffolding on the Imperial Foundry, 1956.

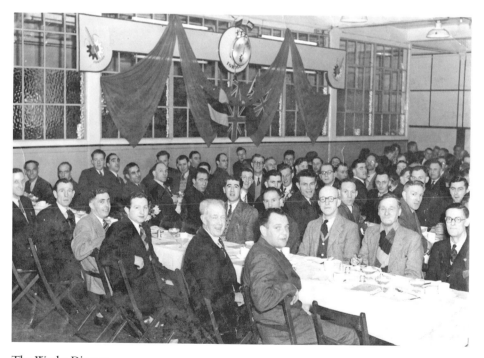

The Works Dinner:
Ford Motor Company works dinner, photographed in the works canteen in the 1950s.

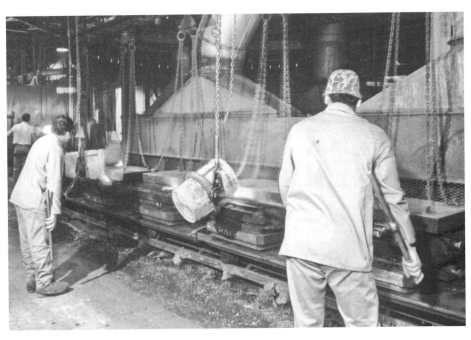

Heavy Work:
Here we see two more metal pourers on the moulding line before the days of automation.

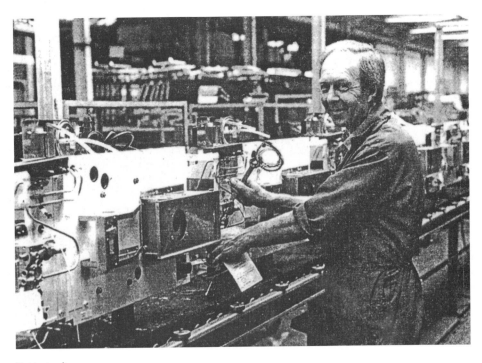

Potterton's:
Another victim of Warwickshire's disappearing industries is Thomas Potterton's. Here we see Bob Bastock working on the assembly line in 1986.

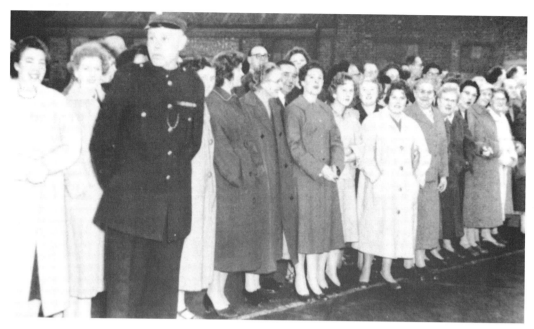

Anticipation:
Waiting for the Queen Mother's visit to Lockheed Automotive products on 6 November 1958.

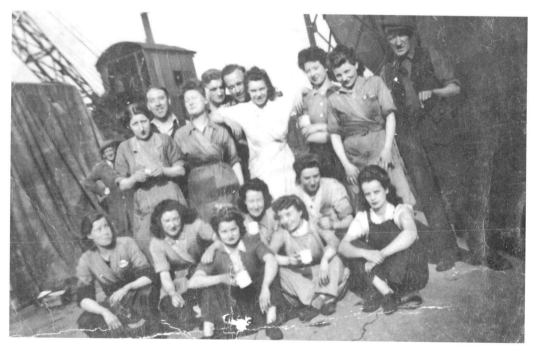

Tea Break:
Taken in the 1940s during a tea break at the Imperial Foundry, the staff of the Core Shop posed for this photograph in the yard, with the Grafton Steam Crane visible in the background. The two ladies in the front row to the left are Pat Corley and Irene D'Arcy.

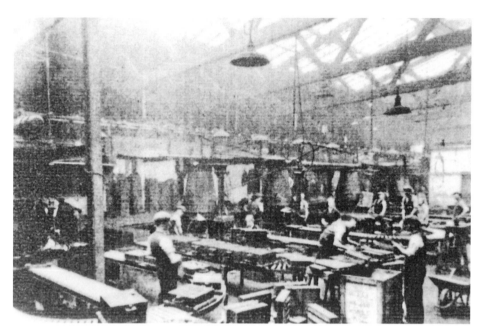

Flavel:
Flavel Foundry in the 1920s.

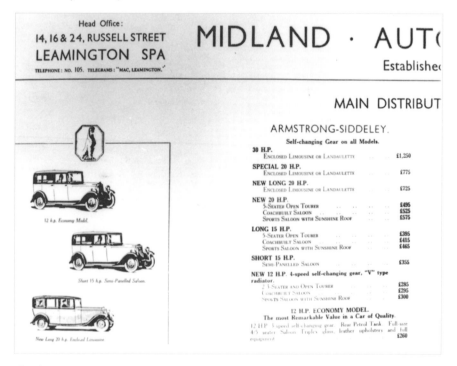

Midland Autocar:
Being well known for its connection with the motor industry, I have included the price lists from the Midland Autocar for Armstrong Siddeley, Morris and Rover, who would have all been manufacturers at nearby Coventry. Yet another example of our disappearing industries.

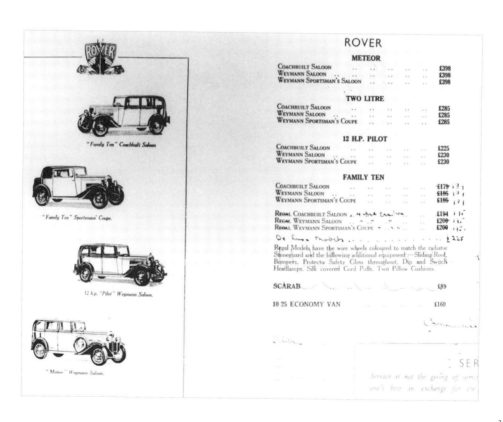

MORRIS

ISIS SIX

Saloon (Sliding Head)	£350
Sports Coupe (Sliding Head)	£350

OXFORD SIX

Coupe (Sliding Head)	£275
Saloon (Sliding Head)	£265
Sports Coupe (Sliding Head)	£285

MAJOR SIX

Tourer	£210
Coupe (Sliding Head)	£225
Saloon (Fixed Head)	£199 10s.
Saloon (Sliding Head)	£215
Sports Coupe (Sliding Head)	£245

COWLEY

Two-Seater	£165
Coupe (Sliding Head	£190
Saloon (Fixed Head)	£179 10s.
Saloon (Sliding Head)	£185
Sports Coupe (Sliding Head)	£215
Traveller's Saloon	£195

FAMILY EIGHT

Saloon (Sliding Head)	£152 10s.
Sports Coupe (Sliding Head)	£175

MINOR

Two-Seater	£100
Tourer	£115
Saloon (Fixed Head)	£122 10s.
Saloon (Sliding Head)	£125
Delivery Van	£125

"Minor" Saloon.

"Cowley" Saloon.

"Oxford Six" Coupe.

ROVER

METEOR

Coachbuilt Saloon	£398
Weymann Saloon	£398
Weymann Sportsman's Saloon	£398

TWO LITRE

Coachbuilt Saloon	£285
Weymann Saloon	£285
Weymann Sportsman's Coupe	£285

12 H.P. PILOT

Coachbuilt Saloon	£225
Weymann Saloon	£230
Weymann Sportsman's Coupe	£230

FAMILY TEN

Coachbuilt Saloon	£179
Weymann Saloon	£185
Weymann Sportsman's Coupe	£185
Regal Coachbuilt Saloon	£194
Regal Weymann Saloon	£200
Regal Weymann Sportsman's Coupe	£200

Regal Models have the wire wheels coloured to match the radiator
Stoneguard and the following additional equipment:—Sliding Roof,
Bumpers, Protecto Safety Glass throughout, Dip and Switch
Headlamps. Silk covered Cord Pulls. Two Pillow Cushions.

SCARAB	£89
10 25 ECONOMY VAN	£160

"Family Ten" Coachbuilt Saloon.

"Family Ten" Sportsmen' Coupe.

12 h.p. "Pilot" Weymann Saloon.

"Meteor" Weymann Saloon.

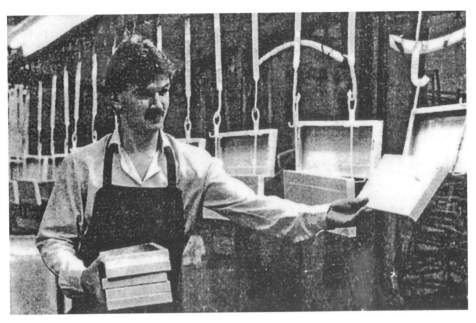

The Paint Shop:
Another photograph of a scene we will see no more. John Lawrence, seen here in the paint shop of Thomas Potterton's, doing a quality check.

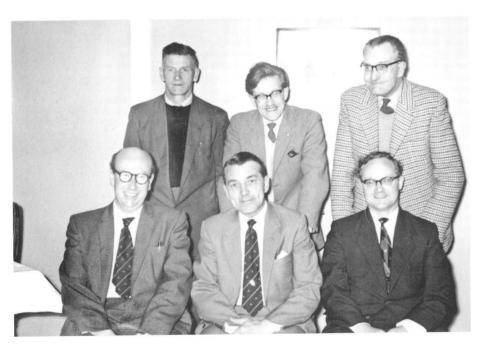

Long Service Presentation:
Taken in the early 1950s in the conference room at the Imperial Foundry, we see the very first 'Barke' shield Golf Team. Among those present was Tommy Buchan, Frank Herbert, John Harris and Anthony Rayment.

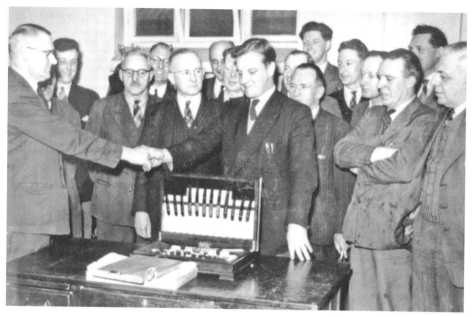

Leaving Gift:
George Jackson, plant manager of the Imperial Foundry, presenting a farewell gift to Ken Rowley in the 1950s.

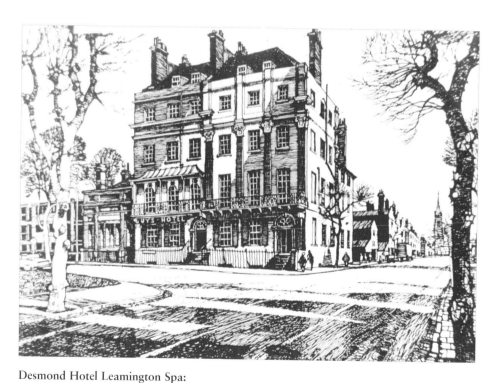

Desmond Hotel Leamington Spa:
The Desmond, a private first class hotel, had forty-two bedrooms and stood on the corner of

The Inspection Department:
Inspection was an important part of any successful business, and inspection at Thomas Potterton was no exception. Here we see Line Inspector Trevor Richards check a metal heat boiler in 1974.

Pauline:
This lovely lady used to arrive in the office every week day at 4.15 p.m., always full of fun. She made sure we all ended the working day at the Ford Motor Company in fine spirits.

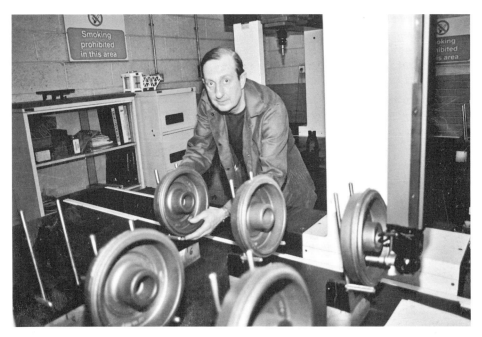

How It Was:
Alan showing the modern castings produced at the Ford Motor Company when they closed in 2007.

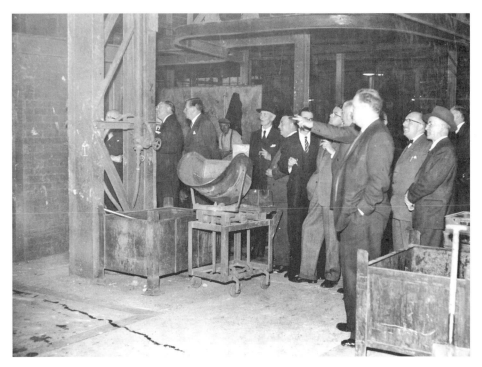

Another Official Visit:
Another look at how it was at the Imperial Foundry in the late 1940s.

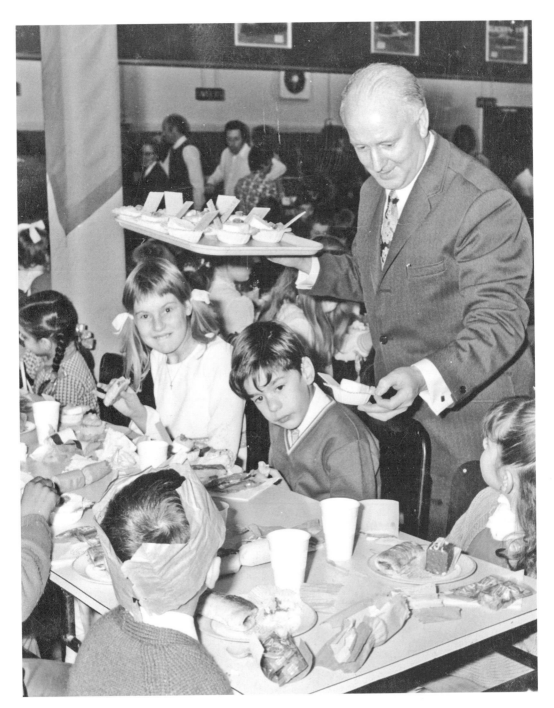

Children's Christmas Party:
In the 1940s and 50s, works often held children's Christmas parties for employees' children. As a child I used to love these events and would look forward to them every year. Here we see a member of staff serving ice cream to the children in the Trusthouse forte canteen at the Imperial Foundry.

The Works Outing:
As the years passed by so did the children's Christmas party tradition, replaced in later years by the children's outing. Here we see employees of the Ford Motor Company Limited getting onto the coach for the yearly outing to Drayton Manor Park. The children's enthusiasm was just too much and they had to get on the coach first to claim their seats.

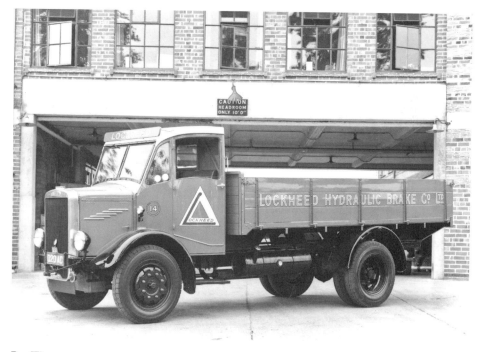

Pre-War:
A pre-war delivery of the new transport lorry at Automotive Products.

A sad sight!
A For Sale board outside the Ford's Queensway site. It says it all.

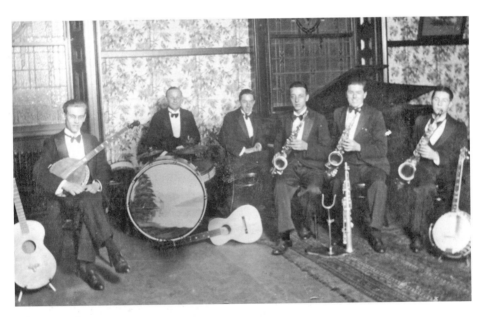

Regent Band:
Dancing was a popular pursuit in days past, and one band who worked the dance circuit at this time was the Regent Band, alias the Rythmetic Band, and later known as the New Rythmetic Band. In the photograph you can see among others Hockey Holt, Eddie Phillips and Harry Warr, who played the zither, banjo, jenna banjo and the guitar.

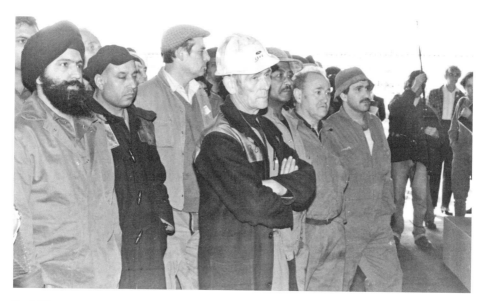

Bud Marx:
Bud Marx, executive director of Ford's Automotive group, addresses a plant audience at the presentation of the Q1 Commemorative Plaque and Flag.

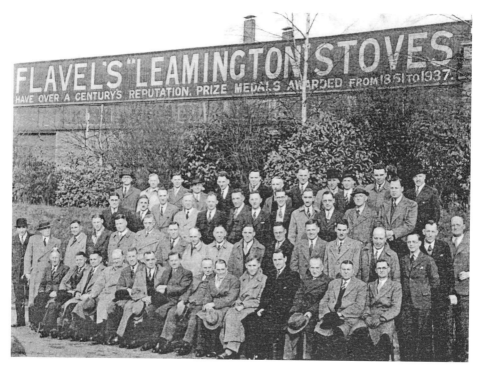

Flavel Leamington Spa:
An historic photograph of senior employees outside the Imperial Works in around 1938, shortly before the foundry was sold to the Ford Motor Company Limited. Len Harbour is standing at the front of the extreme right and George Essex is immediately behind him.

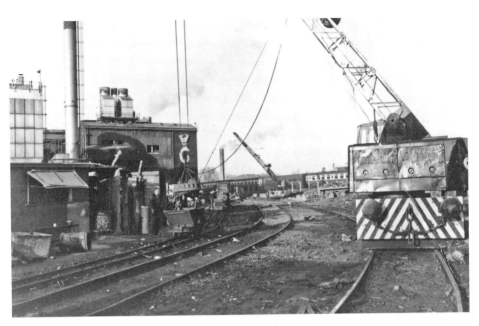

In the Yard:
A lot of back up goes into a successful industry, and here we see the crane at work in the yard.

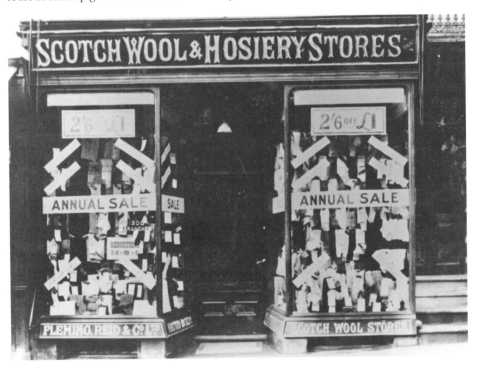

Scotch Wool and Hosiery Store:
Bellman's Scotch Wool Shop traded at 74 The Parade, Royal Leamington Spa. The photograph was taken in the early 1970s. Alas, like so many other old established businesses in the town, it is no longer trading.

A. C. Lloyd's:

A. C. Lloyd's in Camberwell Terrace was established in the town in 1946 by Cyril Lloyd, a carpenter and joiner by trade. The company has won numerous awards in the area for design and building, and is still in business to this day. I have included this photograph as Jaguar, who built the car seen in the photograph, is yet another industrial casualty and no longer operates from Brown's Lane, Coventry, where it thrived from 1945 until 2005.

The Works Schedule:

Engineer Martin Davenport is seen here writing up a works schedule at the Ford Motor Company Limited.

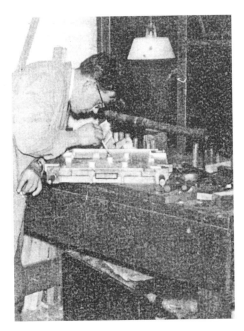
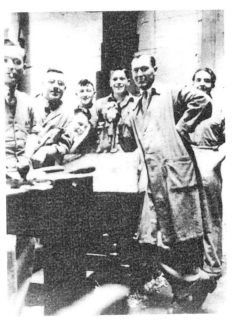

W.C.M. Pattern Company:
In September 1947, three friends, J. Whitehouse, J. Cooper and C. Malin, started the W.C.M. Pattern Company on Clinton Street. The premises were formerly those used by Clinton Valves, which was the original Whittle Factory. They were master pattern makers for a number of local companies. *Right:* George Aitken, Jim Constable, Ted Perkins, Charles Malin, Michael Smith, Jack Whitehouse and Bert Robinson.

The Whittle Factory:
This picture shows the site of the old Whittle Factory in Clinton Street.

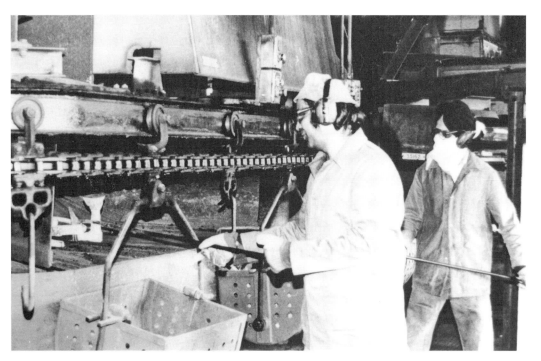

Production Line:
Mahan Singh and Kulwand Singh at
work on the line rake off.

Heiglers Circus:
The old ticket office of the Royal
Pavilion, previously known as Heiglers
Circus, is now an allotment's summer
house and spends its days beside the
River Leam. The town's association with
the circus has long since passed.

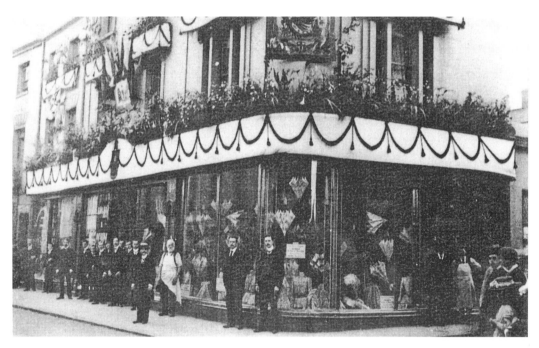

E. Francis and Sons:

E. Francis and Sons was founded in 1840 on Bath Street, Leamington Spa, on the site of Leamington's second mineral spring. The company sold furniture, among other things. In 1965 the House of Francis celebrated its 125th anniversary. Unfortunately the company is no longer in business.

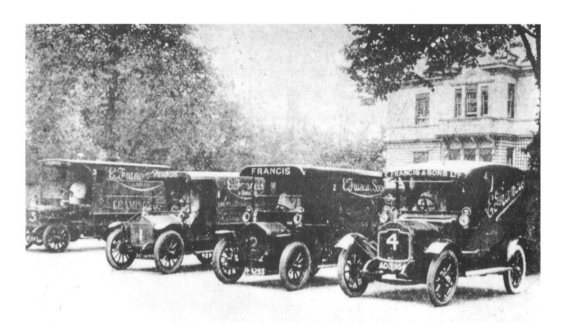

Ready for Business:

A fleet of E. Francis delivery vehicles poised to deliver the goods in the early 1900s.

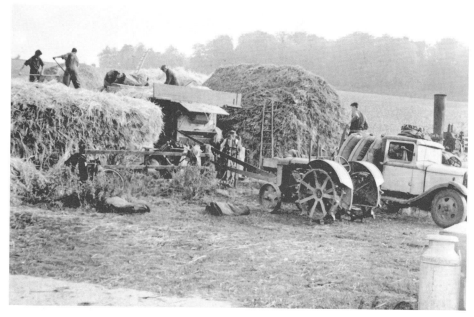

In the Beginning:
Before the discovery of the spa waters in Leamington, the main industry was farming. The threshing machine, and the steam engine that powered it, was one of the few industrial benefits that came to some of the farms.

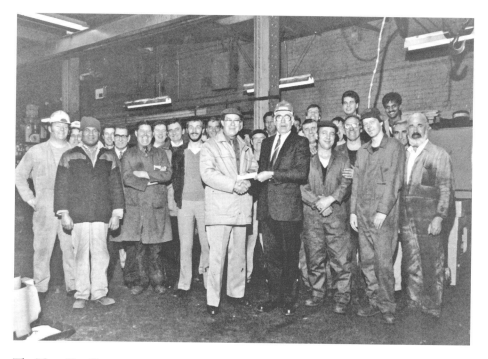

The Time Has Come:
John Courtney, night shift superintendent at the Ford Motor Company, presenting a retirement gift.

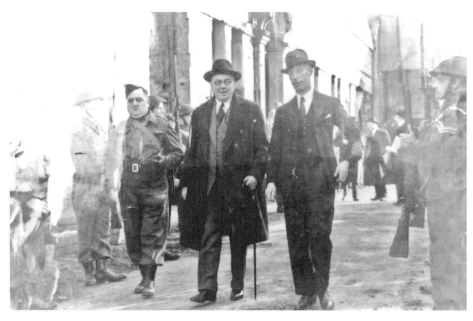

The Grand Opening:
The grand opening of the Imperial Foundry in 1942 by the Rt. Hon. the Lord Perry Harvard KBE, LDD, of Stock.

British Rail Express Parcels:
Running alongside the main railway line out of Leamington Spa Station was the Express Parcel Sidings, where parcels for all over the country were handled. Like other industries in the area, the depot is no more.

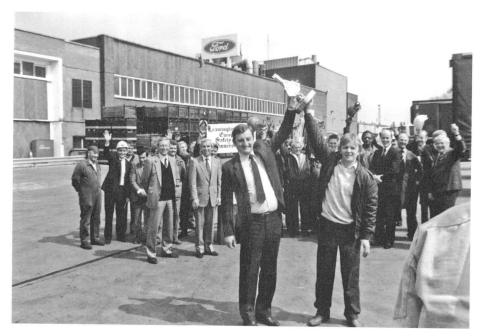

Safety Awards:

Safety has always been a number one priority in industry and never more so than in the past ten years. The Ford Motor Company was no exception and here we see Bruce Bell (plant manager) on the left and Willy Port (convenor) on the right, holding aloft the plant's latest safety award.

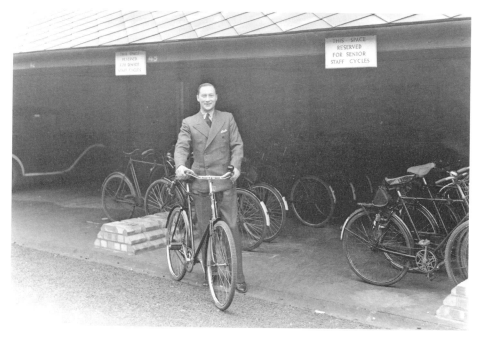

Senior Staff:

This delightful picture is of the senior staff cycle rack in the early 1940s at the Lockheed works.

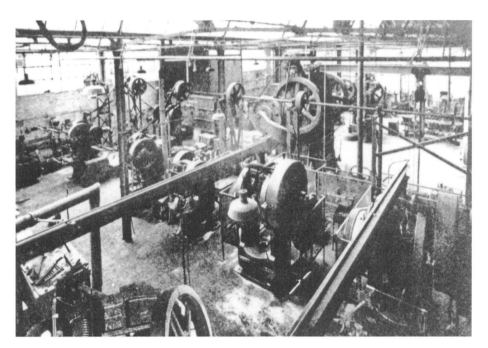

Press Shop:
Here we see the Press Shop at Sidney Flavel's in the 1920s. Although the business was officially recorded as the Eagle Foundry, it was always known locally as Flavel's. The foundry was responsible for the manufacture of cookers, coal and basket grates, and their famous fireplaces.

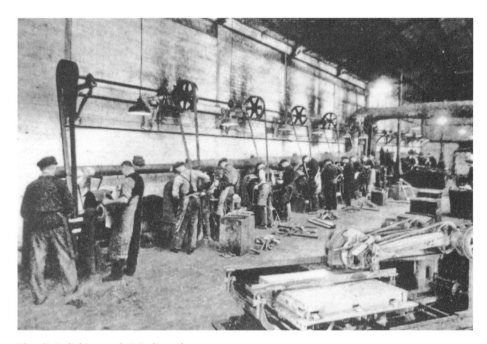

Flavel's Polishing and Grinding Shop:
The polishing and grinding shop at Sidney Flavel and Company Limited in the 1930s.

Cycle Check:
In the early days at the Imperial Foundry the cycle check was in constant use.

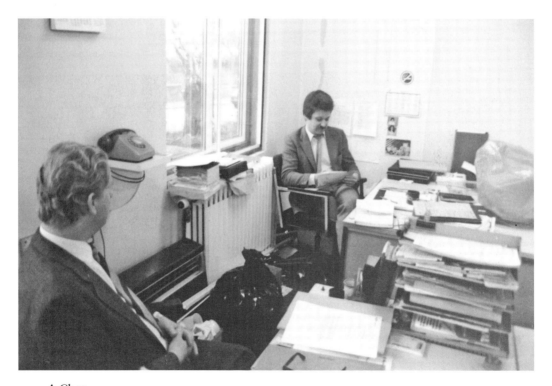

A Chat:
John Moore and Keith Webber enjoying a good chat in the personnel office at the Imperial Foundry.

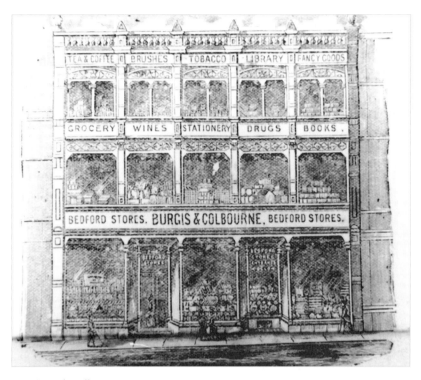

Burgis and Colbourne's:
This lovely old picture shows Burgis and Colbourne's original shop frontage.

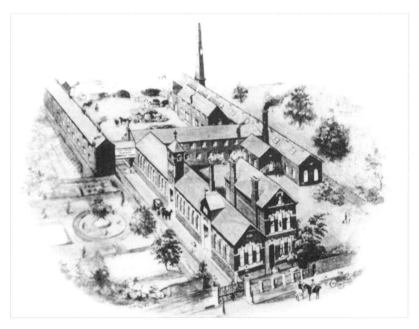

Eagle Foundry:
The original pattern shop at the Eagle Foundry.

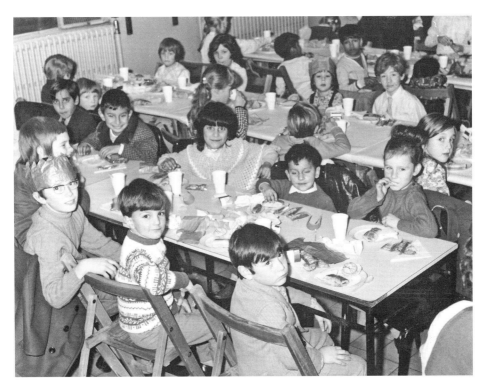

Through Time:
How things change. Here we have children at the Ford Motor Company enjoying a Christmas party in the 1950s, and three of the employees' children in 2006, just off to enjoy a day at Drayton Manor Park on the children's outing which replaced the Christmas parties some years earlier.

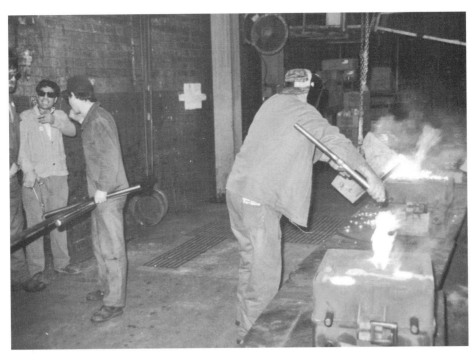

Eric Davis:
For many years Eric travelled from Stratford upon Avon to pour metal at the Ford Motor Company in Leamington Spa. It was a dangerous but rewarding job. A keen footballer, Eric was an active member of the Sports and Social Club for many years.

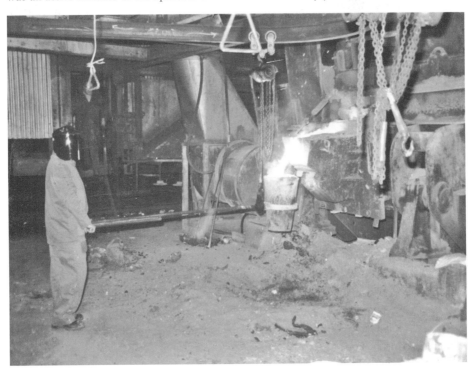

The Works Fete:
Employees of the Imperial Foundry enjoying the annual works fete on a breezy day in the early 1970s. Here is Jackie Kord, Liz Bullas and Ron and Heather Chisolm.

In Recognition of Service:
For many years Mrs Valerie Andrews of Gardner Merchant looked after the Managers' Dining Room at the Ford Motor Company Limited. Here we see Ford plant manager Bruce Bell presenting her with a gift of recognition for services given.

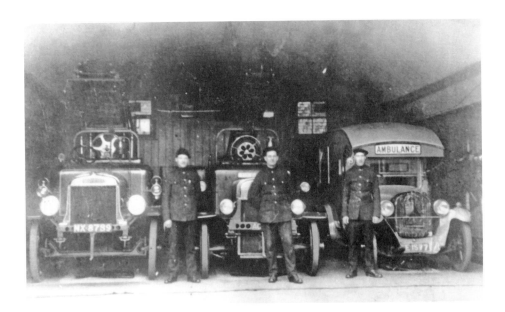

Fire Engines:
Ready for action. The fire engine and ambulance were called to the fire at the Shakespeare Memorial Theatre, Stratford Upon Avon, in 1926.

Schedule and Parts Control:
An important part of any business is stock control, and here we see the manager of schedule and parts control, Derek Bardwell, working on the Ford schedules.

The Rugby Club:
Here we see an action photograph of the Ford Motor Company Rugby Section. The player left of the flag is Wilf Teasdale.

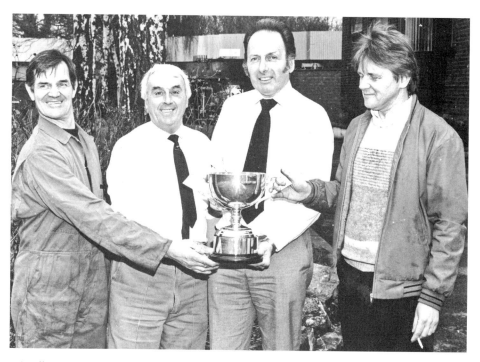

Friendly Rivalry:
It was not all work during the industrial boom, and companies would meet for a little friendly rivalry. Here we see the winners of the annual Potterton/Ford Motor Company Limited friendly cup for bowls. Left to right are Pete Creffield (Senior), George Bubb, Colin Haywood and Billy Port.

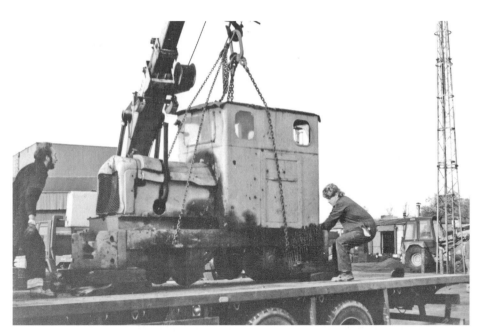

The Planet Loco:
A lovely photograph of the old Planet Loco being loaded onto a low loader for transportation to a museum in Stockport. The Loco spent its days in the east scrap yard at the Ford Motor Company, helping to convey coke and scrap metal which had been placed in skips by the Grafton Steam Crane.

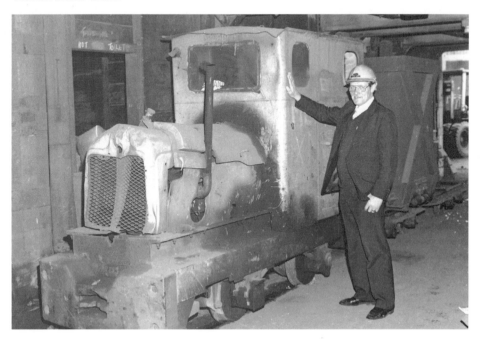

Alan Hunt:
Alan Hunt beside the small gauge Planet Loco at the Imperial Foundry on 1 January 1989. No longer in Leamington Spa, the Loco found a new home at the Stockport Museum.

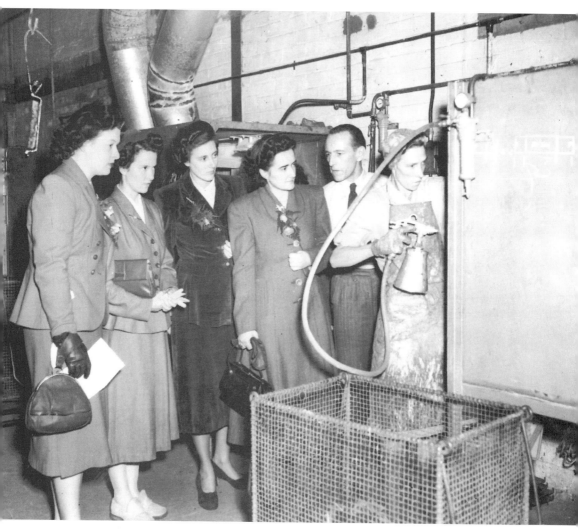

Home Service Advisors:
Here we see the visit of a group of home service advisors to the Flavel factory in 1951. The foreman of the paint shop is Chris Rudd, and the lady with the spray gun is Win Fretwell, who lived in Warwick.

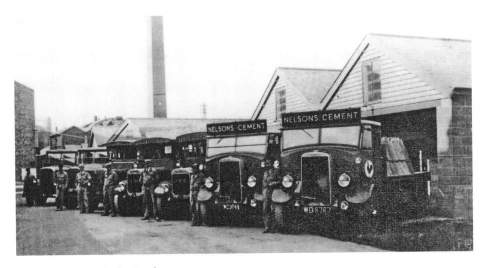

Nelson Cement Works Stockton:
Stockton lies on the outskirts of Leamington Spa and it only seems right to mention their cement works, which is also one of Warwickshire's disappearing industries. The Nelson Cement Works was founded in 1844 by George Nelson and owned by the Nelson family until 1945, when they were acquired by the Portland Cement Company. This photograph of the drivers was taken in 1940. The deep quarries are all that is left of the cement works now.

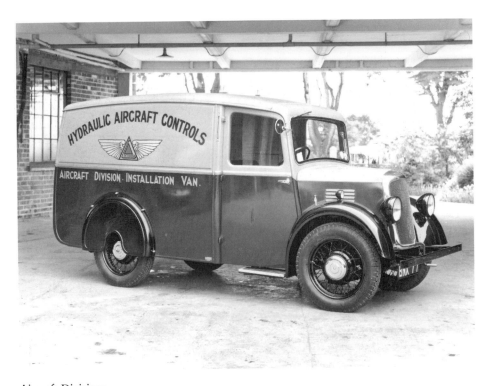

Aircraft Division:
This lovely new van is Lockheed's Aircraft Division installation van, with hydraulic aircraft controls.

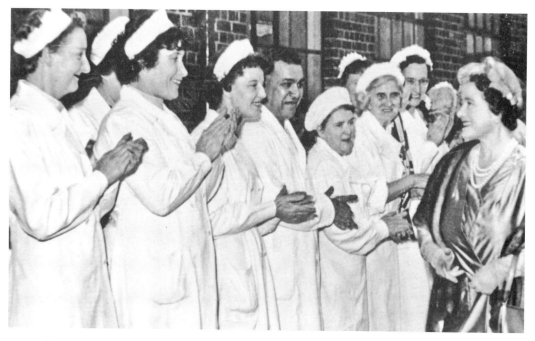

The Queen Mother:
The Queen Mother is seen here exchanging a few words with the canteen staff at Automotive Products on her visit to the factory.

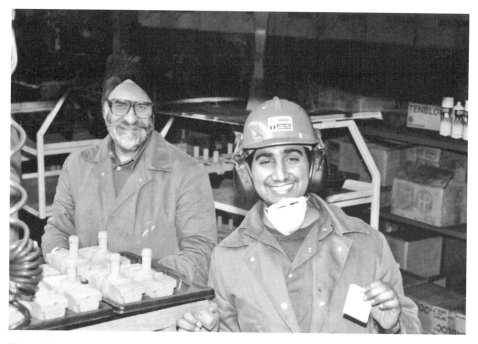

Happy Days:
I love these two smiling faces. They say it all: it wasn't too bad working at Ford's.

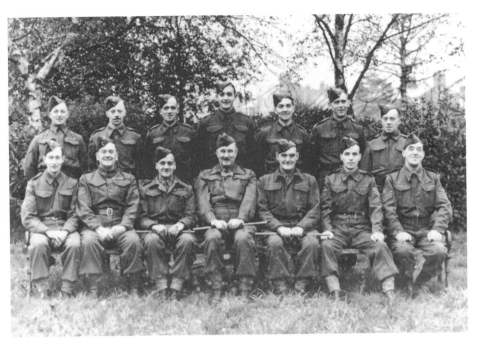

Home Guard:
1st Battalion Warwickshire Home Guard – B (Leamington Spa) Company.

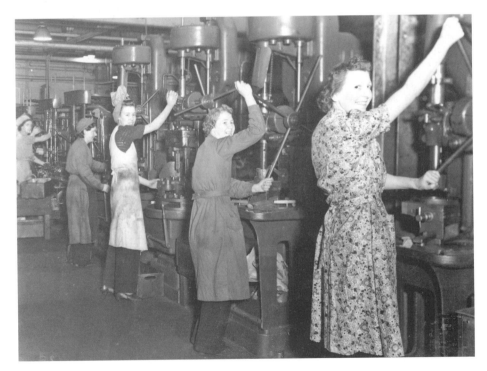

Lockheed Ladies:
Ladies working at Lockheed Automotive Products during the Second World War.

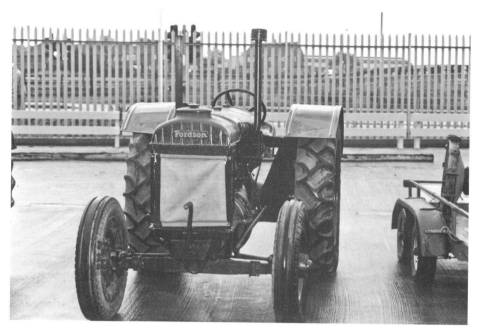

Fordson Tractor:
Perfect for pulling the Fordson plough.

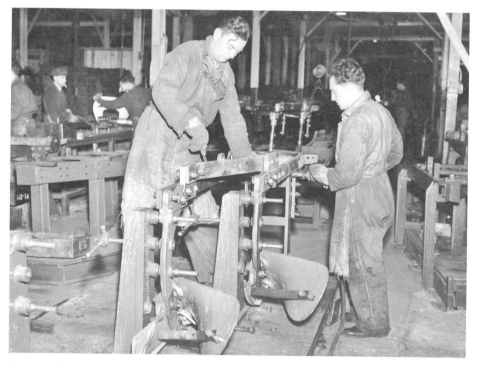

Fordson Plough:
A lovely old picture of the Fordson Plough just coming off the production line at the Imperial Foundry.

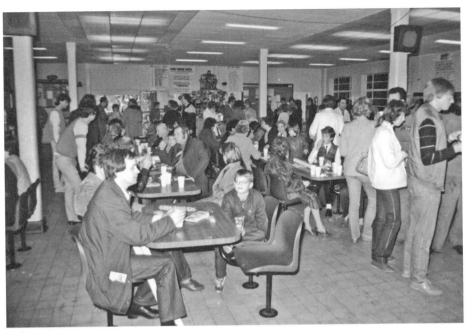

Open Day:
Open Day at the Ford Motor Company Limited when employees' families can come into the plant and see where their loved ones work.

Wedding Anniversary Presentation:
No account would be complete without mention of the last plant manager at the Ford Motor Company, Mr Graham Edwards, seen here presenting a bouquet of red roses to Mr and Mrs Ken Cheshire for their wedding anniversary, which coincided with the pensioners' Christmas party reunion.

Children's Outing:
I have found the children in the Ford Motor Company car park waiting for the coaches to arrive to take them on the children's outing to Drayton Manor Theme Park.

Isobel Brown:
Isobel Brown established the Isobel Brown Agency and Associated Secretarial School in Royal Leamington Spa in 1963. By 1966 the staff placement side of the business had grown to such an extent that the school was closed. Some twenty-eight years later the agency, which operated from Victoria Terrace, had handled in excess of ten thousand candidates for office jobs of all kinds, and had extended operations to include Warwick, Coventry, Stratford upon Avon, Banbury and Rugby. Since its commencement, the agency was acquired by Stewart Baxter with Isobel Brown remaining as senior consultant. In the picture we see Stewart Baxter and Isobel Brown. Despite its success, the business closed a few years ago.

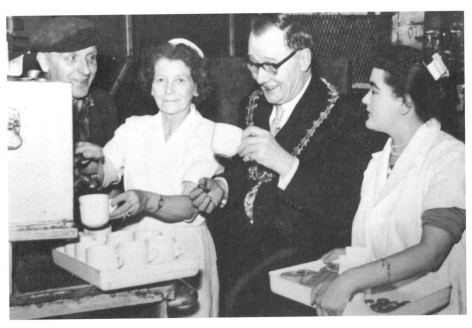

Tea Up!
The Mayor sampling a cup of tea from the canteen trolley, which would be pushed into the various departments in the plant for the workers at the Imperial Foundry.

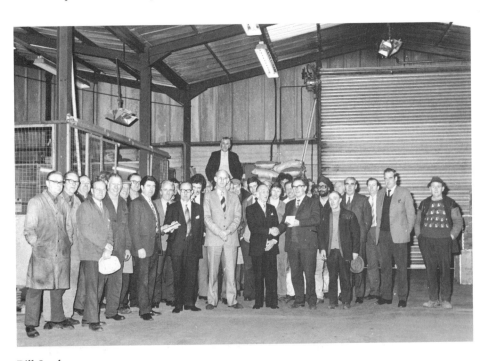

Bill Sturley:
Bill Sturley, PP and C manager, posed for this photograph with members of his department at the Ford Motor Company.

The Mayor's Visit:
Traditionally, the Mayor would visit the Imperial Foundry in Royal Leamington Spa every year, usually in the spring. Here we see, left to right, George Jackson (plant manager), Beryl Elleman (secretary), -?-, Rolly Wood (works manager), Lady Mayoress, Anthony Rayment (assistant manager) and -?-, on the yearly visit. This tradition sadly fell casualty to financial cutbacks.

Flavel's Staff Outing:
Taken in 1927, this delightful photograph shows Flavel's staff about to enjoy a good day out. Among those in the photograph are Miss Turner, Sidney W. Flavel, Joan Gardner, Nellie Webb, Vi Woodward, Sid Grimwood, Mr Sidwell, Miss Short, Miss Tourney, Bill Box, Jimmy Ledwith, Ted Crowe, Doll Cogbill, Sheila Clements, Bill Marlin and Fred Bryson.

Oh Dear!
Harry standing outside his security lodge in Princes Drive, Leamington Spa, when the builders arrived to give him a make-over at the Ford Motor Company Limited.

The Clarendon Hotel:
The Clarendon Hotel was built in the north-east corner of Lansdowne Place in 1830, and is now converted into luxury flats and apartments.

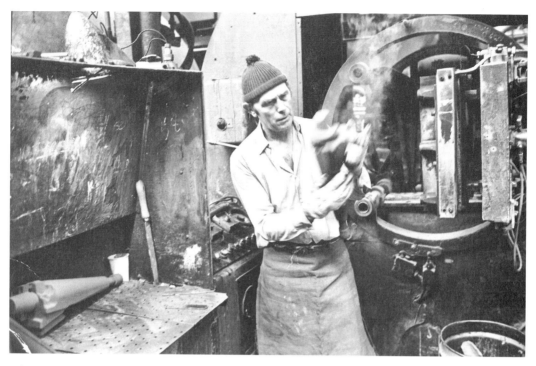

What, no P.P.E.?
These photographs were taken in the days before P.P.E. (personal protective equipment) became law, and although the operatives would probably have been wearing safety shoes, there was no sign of hats, goggles and ear muffs.

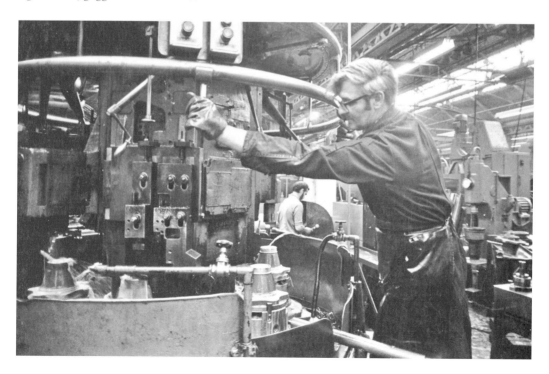

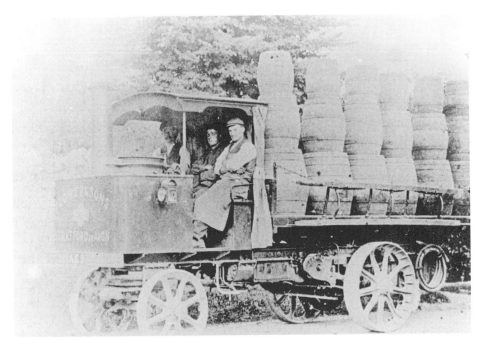

Flower and Son:
The Flower and Son Brewery dray, photographed at Leamington, where the company had a depot. The steam driven lorry, the metal wheels, and the barrels of beer all convey the 'feel' of the good old days.

Ford Motor Company:
The Ford Leamington plant in the 1980s.

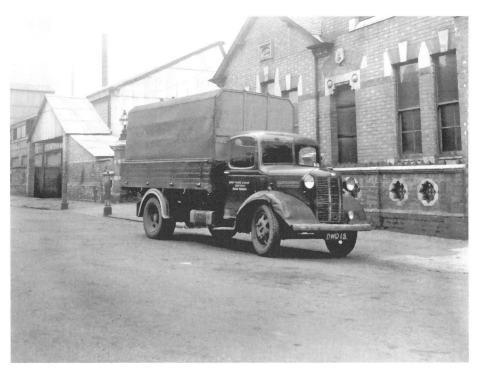

Sidney Flavel:
One of the Sidney Flavel delivery fleet photographed outside their Leamington Plant.

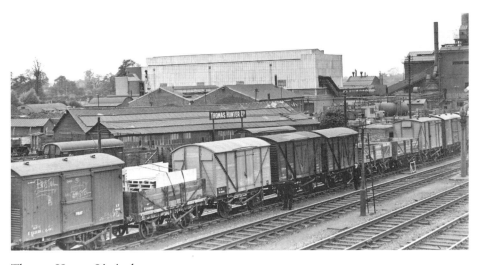

Thomas Hunter Limited:
From the main railway line, we see the premises of Thomas Hunter Limited in busy times. Another casualty of Leamington's declining industry I am afraid.

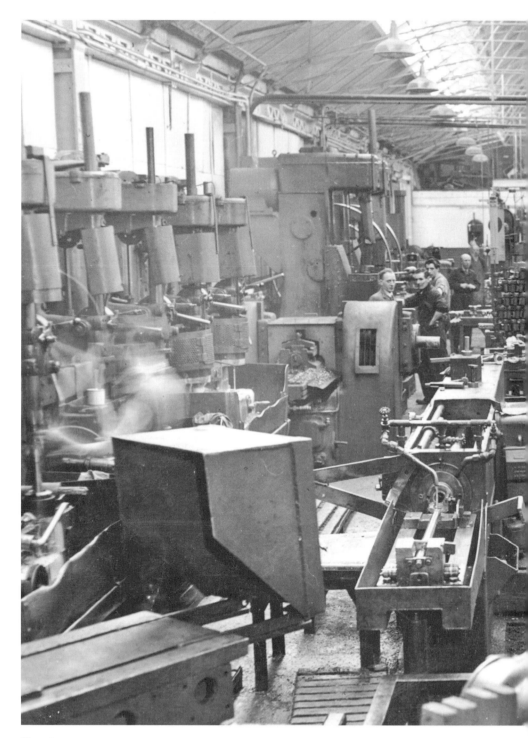

How it was:
Photographed in the 1940s, we see how life was on the shop floor before the days of safety hats and personal protective equipment.

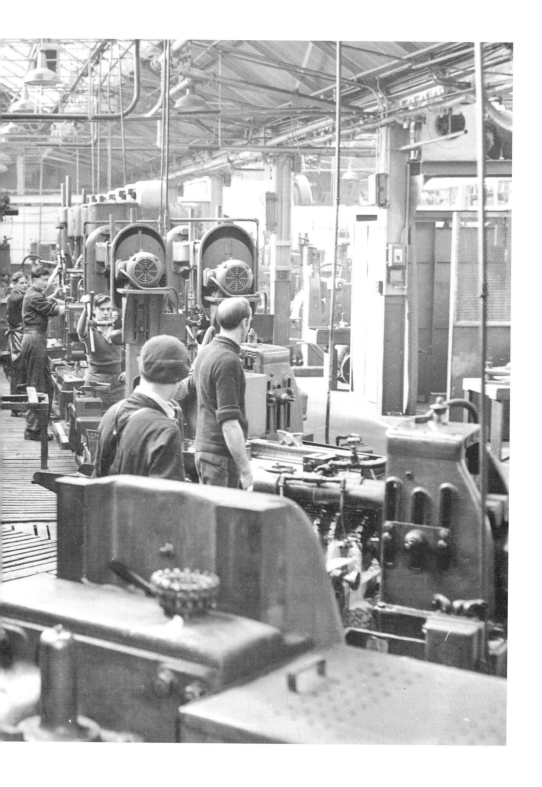

As Time Goes By:
I have included these two photographs as they show beautifully the advancement of the motor car over the years. The top photograph shows children getting ready for a trip in the family's Ford Eight motor car, and the bottom photograph shows Bridget Halpin, supervisor of the quality control and the spec lab, sat at the controls of a top-of-the-market Ford car, at the Ford Motor Company. Both vehicles would have had parts manufactured at Leamington.

Mr and Mrs Rutkowska:
Ford pensioners Mr and Mrs Bob Rutkowska had called into the office to collect their tickets for the company's pensioners' Christmas party reunion. Mr Rutkowska worked for many years on night shift and Mrs Hilda Rutkowska worked at Automotive Products.

Mr Charles William Gardner:
I don't know if it was because of the war, but the Mayor's visit to the Imperial Foundry certainly seems down in numbers in 1944. Here we see the Mayor, Mr Charles William Gardner, and guests standing on the steps of the main office entrance in Princes Drive.

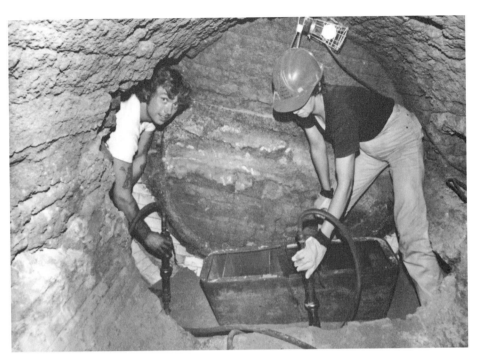

Furnace Relines:
Another casualty of time is Furnace Refractories of Leamington Spa. The lady on the right, Mrs Carol Theobold, was the country's only furnace reliner and rammer. Here we see Carol and an associate relining an induction furnace.

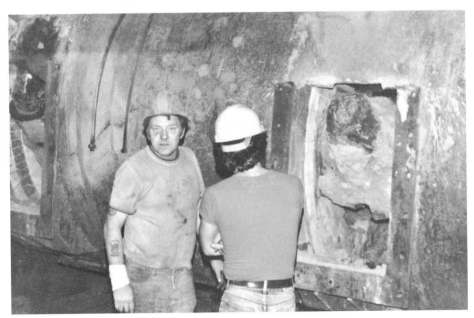

Furnace Maintenance:
Fred Theobold, the proud owner of Furnace Maintenance, about to reline a local furnace, with the help of an unknown assistant.

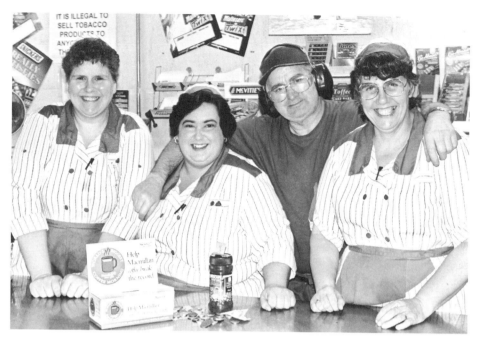

Gardner Merchant:
These lovely ladies lost their jobs when the Ford Motor Company Limited closed its doors. They were contract labour and worked for Gardner Merchant who undertook the company's catering requirements for many years. From left to right we see Meryle, Sharon and Dot.

Taj Mahal:
The 1958 Taj Mahal goodwill coach tour from Leamington to India was the fulfilment of a dream for the proprietor of West End Garage, Ken Chamberlain, seen on the far right.

CHAS. T. CROWDEN,
ENGINEER,
Motor Works, LEAMINGTON.
(Near BIRMINGHAM.)

MOTOR VEHICLES
For Light and Heavy Traffic in Stock or Progress.
Patent Motors, Gearing, Axles, Steering Gears,
Road Wheels, Springs, Frames, etc.

CHAS. T. CROWDEN is prepared to give expert advice to Engineers, Carriage Builders, &c., and supply Designs, Patterns, Templates of Motors, and Parts under his and other well-known tried Systems and Patents. For further particulars apply at his Motor Works, Leamington, where trial machines can be inspected, seen, and tested.

Telegrams:—" MOTOR," Leamington.

Charles Crowden:
Charles Crowden moved from Bath to 10 Eastnor Grove, Leamington, in 1898. At his Motor Works at Packington Place, he manufactured the only type of car produced in Leamington, the Crowden Light Car. He remained in the town until 1904, when it is thought he retired. The car in the picture was owned by Mr M. J. Carpenter until around 1930, when it was sold. His youngest daughter is sitting in the car.

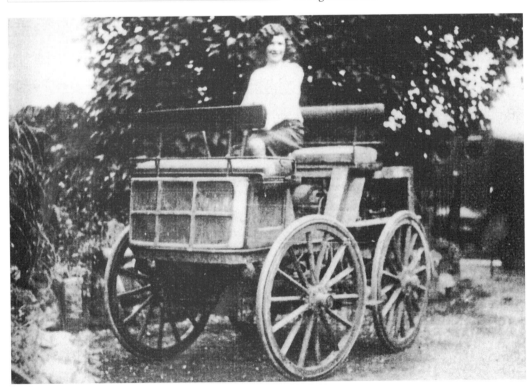

Rene Randall:
Mayor Rene Randall and Ron
Lovett, plant manager of the
Imperial Foundry, talking moulds on
a company visit.

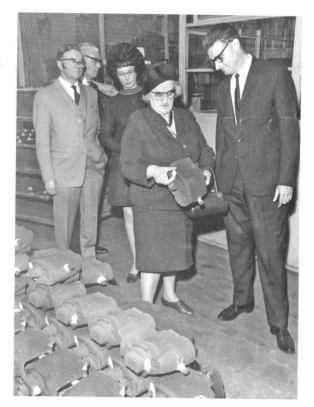

Locomotive Shed:
Unfortunately the Milverton
Locomotive Shed was also closed.

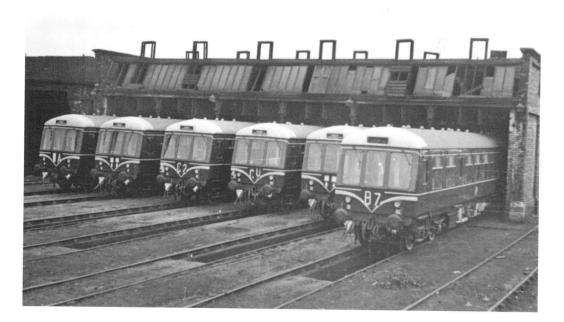

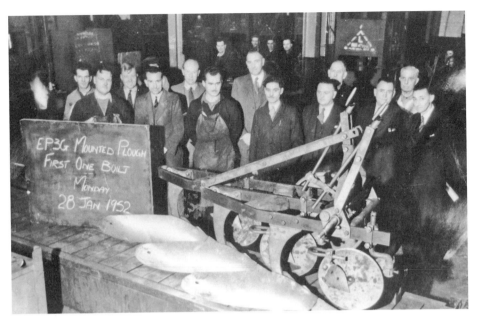

Mounted Plough:
The first mounted plough built at the Imperial Foundry in Princes Drive, Leamington Spa, on Monday, 28 January 1952.

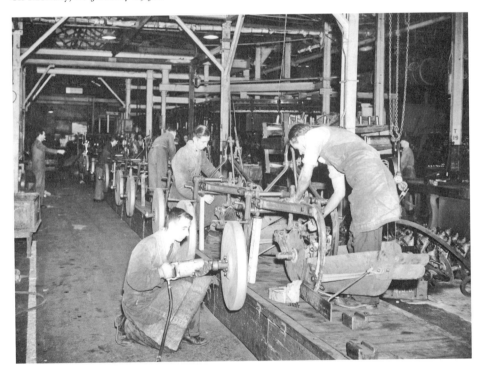

In the Good Old Days:
This is a real step back in time and shows the early days of the plough share manufacture at the Imperial Foundry.

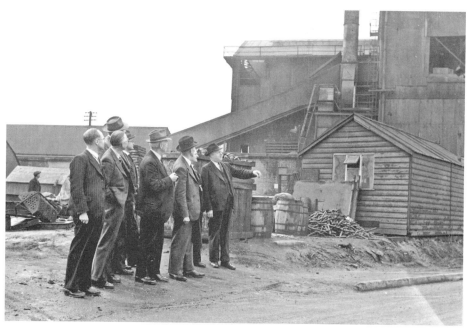

The Yard Inspection:
This photograph shows a group of visitors to the Imperial Foundry being shown around the yard in 1944.

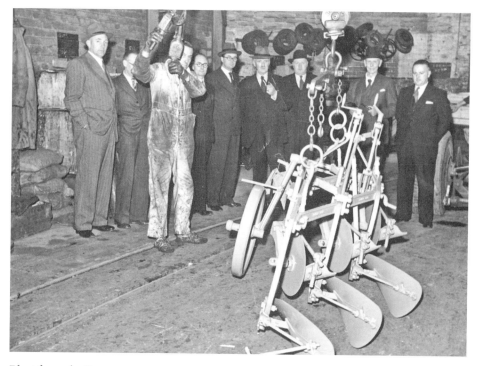

Blast from the Past:
Another blast from the past photographed in the late 1940s at the Imperial Foundry.

SIDNEY FLAVEL
1819-1892.

RADCLYFFE & CO.

OLD TOWN FOUNDRY,

LEAMINGTON SPA.

KITCHENER MANUFACTURERS

AND

GENERAL IRONFOUNDERS.

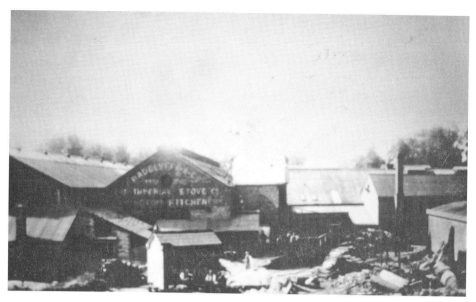

Radclyffe Imperial Foundry:
This is the first foundry built on what was finally to be known as the Ford Motor Company site.

The Pensioners' Christmas Party Reunion:
For many years the Ford Motor Company Limited subsidised the pensioners' Christmas party reunion, and here we see the pensioners enjoying themselves at the Spa Centre, the venue for many years.

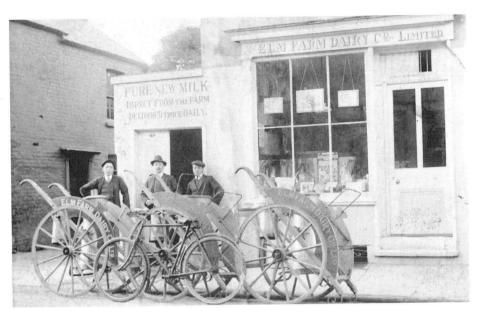

Elm Farm Dairy:
Elm Farm Dairy Company Limited, Regent Street, *c.* 1900. Pure fresh milk was sold from their carts.

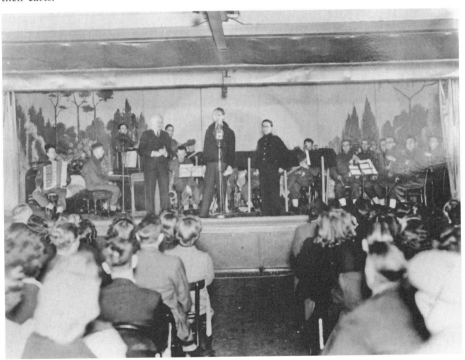

Workers' Playtime:
Workers' Playtime was a popular radio programme during the Second World War and for a period afterwards. Performances in work canteens were given during the dinner hour and artists and musicians would be brought in to entertain employees.

Shorthand Typists:
Photographed in 1948, these four shorthand typists were employed at Lockheed Automotive Products in the shorthand office. Back row, left to right, are Rhona Bayliss and Anne Oliver, and front row, left to right, are Doris Sharman and Helen Hurst.

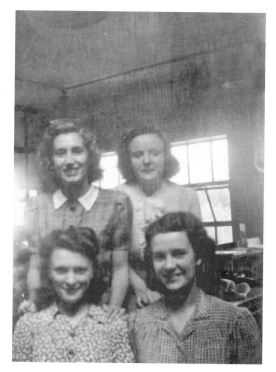

Social Scene:
Companies were great at instigating social gatherings and here we see left to right Arthur Hinksman, Don Brown, Mrs Brown and Dick Houghton enjoying one such occasion at Ford's.

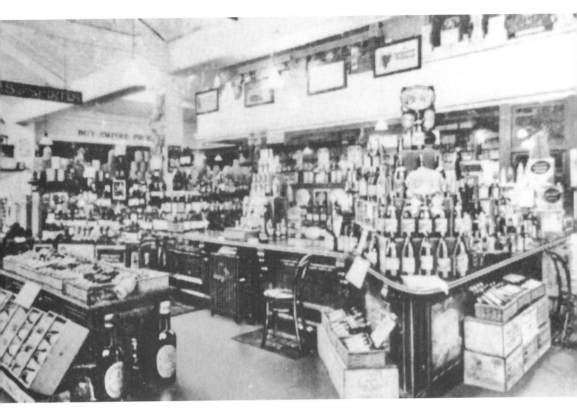

Shop Floor:
Goods for sale at Burgis and Colbourne's.

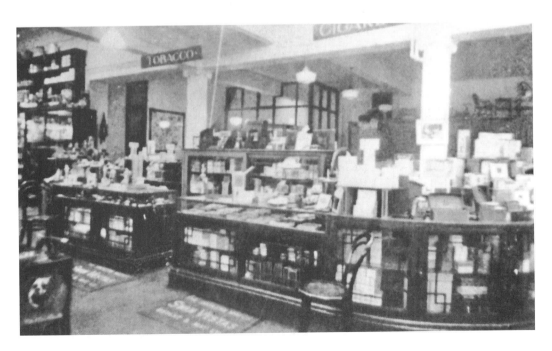

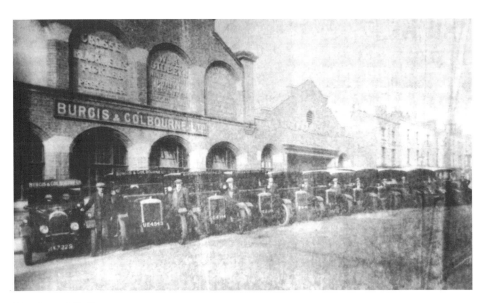

Burgis and Colbourne:
These lovely old pictures show the Burgis and Colbourne delivery fleet in the 1930s and the original shop frontage on the Parade in Leamington Spa. Alas, this family business is no more.

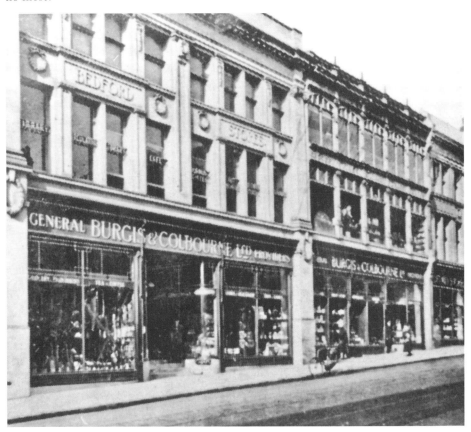

Sid Thornton:
Pensioner Sid Thornton travelled from Barford to work in the finance office of the Ford Motor Company for many years.

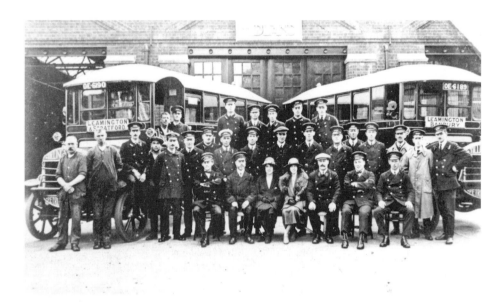

Midland Red:
The local Midland Red Bus Crew posed for this photograph in 1922. The buses were Tilling Stevens Petrol Electric buses.

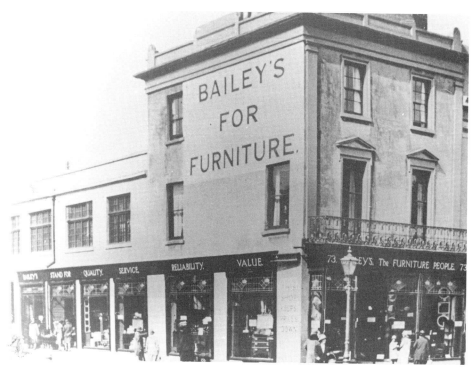

Bailey's:
Bailey's Furniture Store served the town for many years in Warwick Street until September 1992, when it fell casualty to the recession. It was a family business concentrating mainly on exclusive furniture, although in its early days perambulators such as the elegant Silver Cross were sold there.

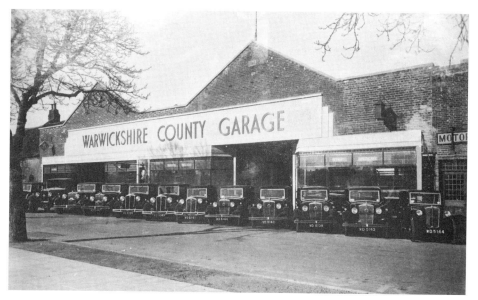

County Garage:
What a lovely sight. A row of vehicles for sale at the Warwickshire County Garage.

Political Visit:
Prime Minister Sir Anthony Eden on a visit to Ford Motor Company Limited.

Demonstration:
A Ford tractor and the implements manufactured at the Imperial Foundry.

In the Good Old Days:
In days past the lorries were loaded from the loading bay at the Imperial Foundry in Princes Drive. As you can see, traffic was a lot lighter in those days.

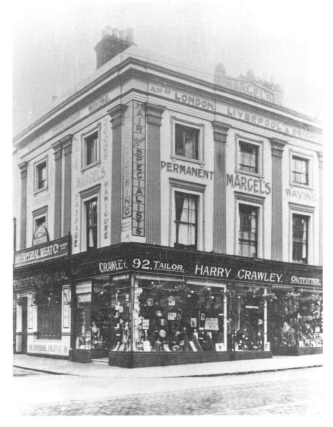

Harry Crawley's:
Harry Crawley's tailor's and outfitter's shop traded in the town for many years. It stood on the corner of Regent Street and the Parade, and was known as Logan's before the Second World War.

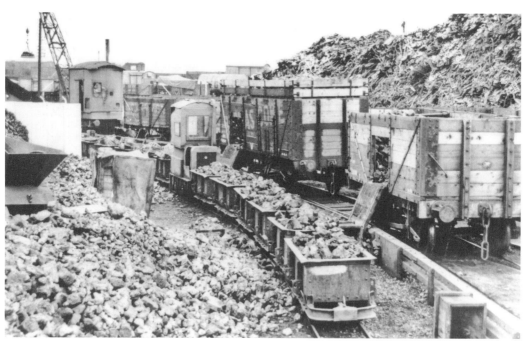

The Scrap yard:
The scrap yard with the Planet Loco in action at the Ford Motor Company.

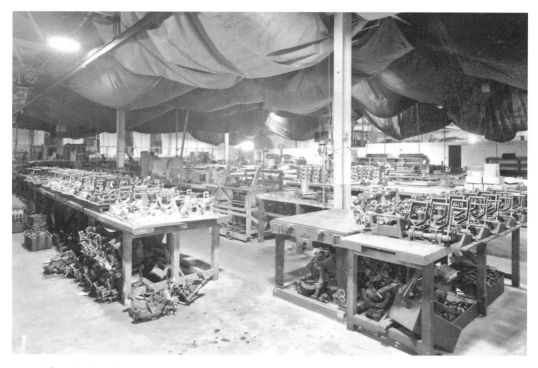

After the Bombing:
Another view of the aftermath of the bombing at Automotive Products.

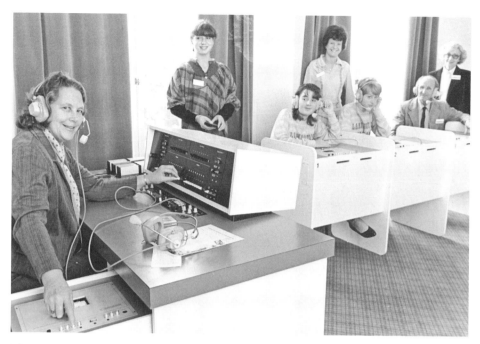

The Language School:
Here we see Mrs Townsend on the Master Console and the students recording at the Leamington Language School.

Engineering:
One of the most important areas of any large business is the engineering office, and here we see Brian Templeton, manager of plant engineering, going through the drawing sheet and schedule with engineer Mick Smith at the Ford Motor Company.

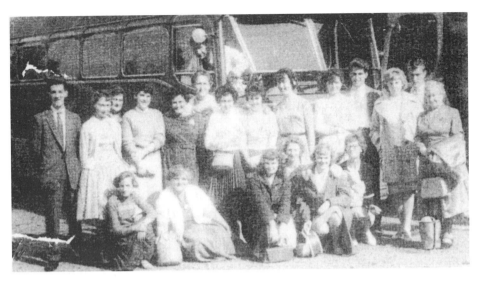

Henry Griffiths':
An outing to Clacton was on the cards for the works staff at Henry Griffiths and Sons jewel
factory, Tachbrooke Road, in 1959.

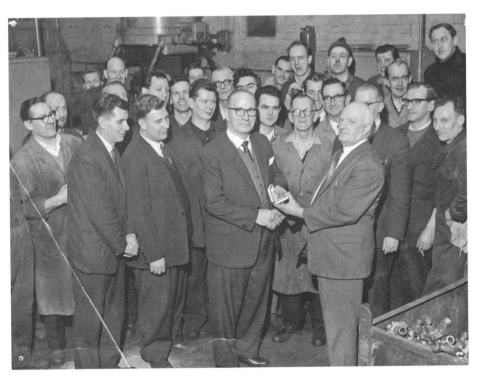

Retirement Party:
Len Henson, machine shop superintendent, presenting a retirement gift from the department
at the Imperial Foundry in the early 1960s.

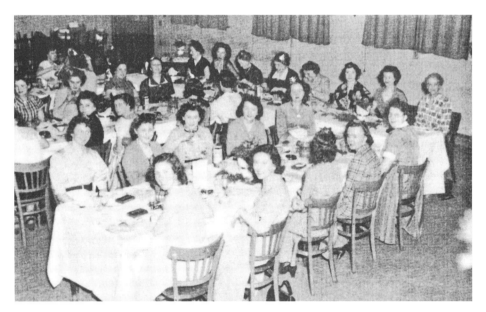

Typing and Shorthand:
The ladies of the typing pool and the shorthand typists enjoy their Christmas party in the Lockheed Hydraulic Company's ballroom in the mid 1940s.

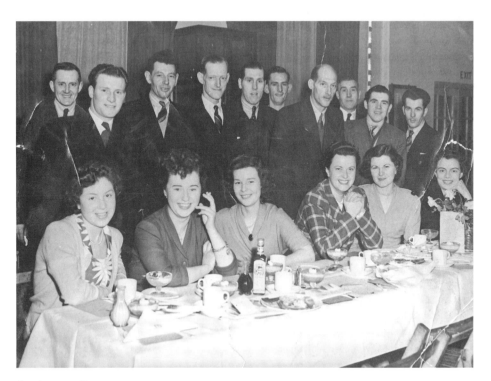

Anniversary Party:
Photographed in February 1951, we see employees of the Imperial Foundry enjoying an anniversary party.

A Shared Moment:
Ford Motor Company plant manager Bruce Bell exchanges a few words with a pensioner at the works Christmas party reunion.

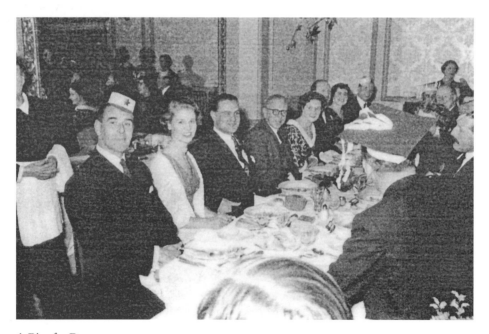

A Bit of a Do:
Sales representatives and office staff at a party at the Regent Hotel in Leamington Spa in the mid 1950s.

The Manager of Gardner Merchant:
Andy Wild, the canteen manager for
Gardner Merchant, seen here enjoying his
leisure time, winding the church clock at
Cubbington. Andy successfully ran the
canteen for many years, which was quite
an achievement as it was a large canteen
running around the clock service.

The Production Line:
100,000 implements roll off the line at the
Imperial Foundry for the Ford Tractors on
30 January 1952.

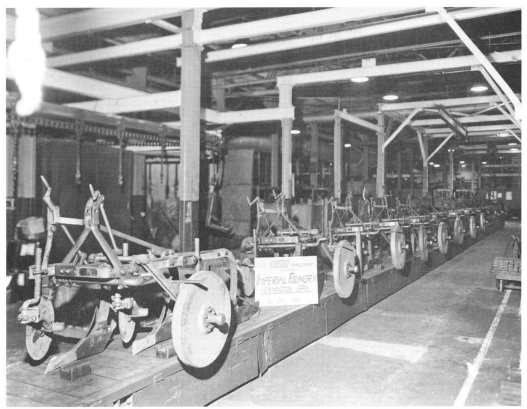

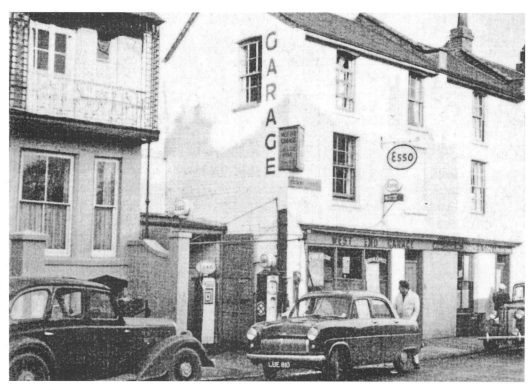

West End Garage:
A Tilling Omnibus with the driver John Combray ready for action in the 1950s. West End Garage
ran their business in Regent Street, Leamington.

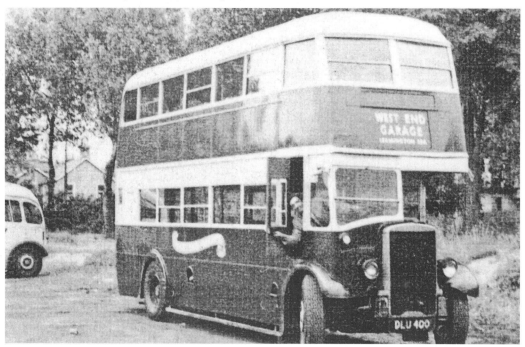